MILE O' MUD

THE CULTURE OF SWAMP BUGGY RACING

MALCOLM LIGHTNER

Introduction by Padgett Powell

powerHouse Books
Brooklyn, NY

FOR MY SON COLTON WITH LOVE

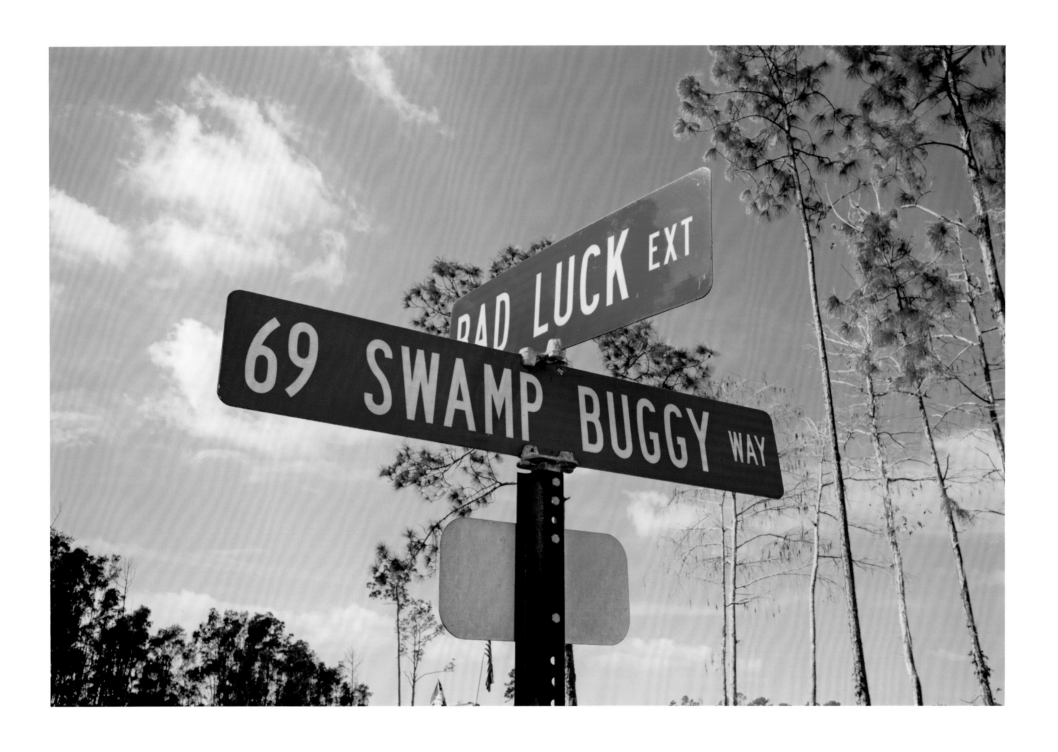

4

"There, but for the grace of God, go I."

After moving to New York in 1999, I began to think about my heritage and the place where I grew up, Naples, Florida. I am a fourth-generation, native Floridian. My mother's family goes back to the settler days, when this region of South Florida was wild and largely uninhabitable swampland. My ancestors mostly farmed, fished, and hunted, and eventually they ventured into land development and real estate. My great grandfather Forest Jehu Walker was born in Settler's Creek (now Bonita Springs) on June 9, 1897. Among other accomplishments, he introduced the now standard waterfront development concept of parking your car in the front yard and your boat in the back. In 1949, he and his sons James Lorenzo and Robert Lewis ("R.L.") purchased 294 acres for $30,000. It took almost 14 years to build Aqualane Shores and sell all the lots. One of Naples' first waterfront communities, its homes are now valued at well over a million dollars each.

Looking back, I began to reminisce about the landscape that was so familiar to me as a child: the pine and palm trees, the swampland, the alligators, the heat and humidity, and the sunny blue skies and pristine green waters of the Gulf of Mexico. I remembered how I used to go on expeditions in search of gopher tortoises in the empty lots of Naples Park, a residential community located in North Naples just a few blocks from the beach. And I recalled the mud-racing event that originated in my hometown, swamp buggy racing at the Mile O' Mud. The homespun buggies and their drivers represent a specific Floridian vernacular and play a central role in the cultural identity of Collier County. As a boy, I lived in a trailer park located down the street from the first official swamp buggy track off Radio Road. The track was later relocated to the Florida Sports Park off Rattlesnake Hammock Road at the intersection of Route 951, where it resides today.

My Great-uncle R.L., one of the original swamp buggy drivers, helped to formalize the race into a legitimate sporting event, which officially launched in 1949. In his custom-built buggy, Flying Saucer, R.L. was Swamp Buggy King in 1951 and 1952. In 2003, I went to visit my great-uncle Lorenzo at Naples Community Hospital, shortly before he passed away. He talked about his brother R.L. and the early days of Naples and racing swamp buggies. He told me how he had to ride his bike "real fast" across the dirt road intersection of what is now referred to as Four Corners so the "panthers wouldn't git 'im." He also spoke of the dedication of the Everglades National Park by president Harry S. Truman on December 6, 1947. He said he had film footage of the president cutting the ribbon at the ceremony.

Needless to say, a lot has changed since those pioneer days and my childhood years. Four Corners is no longer a dirt road intersection surrounded by thick, subtropical forest, and there are no more empty lots in Naples Park. In

Florida, gopher tortoises are on the endangered species list, categorized as a "threatened species," and are found only in a few designated areas. The small town I once knew is no longer recognizable. The beach access has become largely privatized, and the landscape is marked with condominiums, golf courses, and strip malls. To my surprise, the trailer I once lived in is still there, and the swamp buggy races have endured, despite urban development and political pressure to sell off the desirable acreage owned by Swamp Buggy, Inc.

Before embarking on my "Mile O' Mud" project in October 2002, my encounters with the races consisted of a few abbreviated visits to the track with my mother, who was not interested in the races but in locating my father, who had gone missing for several days. This frequent occurrence eventually led to their divorce. In the 1970s, the swamp buggy races were somewhat like the Wild West, where people carried guns in holsters and drank heavily. It was a "locals only" party and not exactly a wholesome family event. Every October, however, my mother took my sister and me to the Swamp Buggy Parade, which marked the opening of hunting season and kicked off the fall racing season. The parade was a community celebration of swamp buggy culture, where drivers could show off the individuality and mechanical ingenuity of their buggy designs. Women donned calico frocks, a Swamp Buggy Queen was crowned, and men sported bushy beards in anticipation of the Swamp Buggy Days beard contest.

I began to photograph swamp buggy racing to pay homage to my family heritage and to document a rare slice of Americana. On my first visit to the track, I drove into the parking lot of the Florida Sports Park, heard the engines of the buggies roar, and witnessed the great plumes of water trailing behind the boat-dragster hybrids. I could feel the vibrations from the raw horsepower pound against my chest, and it almost took my breath away. I thought to myself that this was going to be fun! The races occur three weekends out of the year, and I managed to make the trip at least once a year from 2002 to 2013 except 2005, when the races were cancelled due to Hurricane Wilma.

In my own mind, this project felt like time travel. I experienced firsthand the people and culture that were a large part of my parents' life that I had never witnessed but that felt somehow defining. Initially, it was the buggies themselves that attracted me, but I soon began to discover endless narrative possibilities and connections among the drivers, spectators, and enthusiasts. I unveiled family connections that I did not know existed and heard numerous stories about my father, who had the reputation of a hard worker in the plastering and construction community. He was an all-around tough guy, someone you would not want to mess with. While in Naples, I sometimes stayed with my father and came to realize that behind the tough exterior is a sociable, giving, and sensitive man. He took me to the home of Lonnie Chesser of the legendary Chesser racing family where they talked about the good ol' days. I will always

remember when my father called me "buddy" for the first time and wiped down the early morning condensation on my car's windshield to assure I would have a safe drive.

I came to understand Swamp Buggy Racing as a metaphor for life's daily struggles and the innate drive to overcome obstacles against great odds while trying to maintain a sense of humor and grace. The races demonstrated to me the all-American desire to compete to win, as well as the power of family and community.

Going to the races has also been a bittersweet experience. While it was exciting and adrenaline-filled at the track, the community and my family have seen better times. I am reminded that life is indeed short and full of unexpected bumps in the road. All the more reason to let go and enjoy the ride.

Malcolm Lightner, 2013

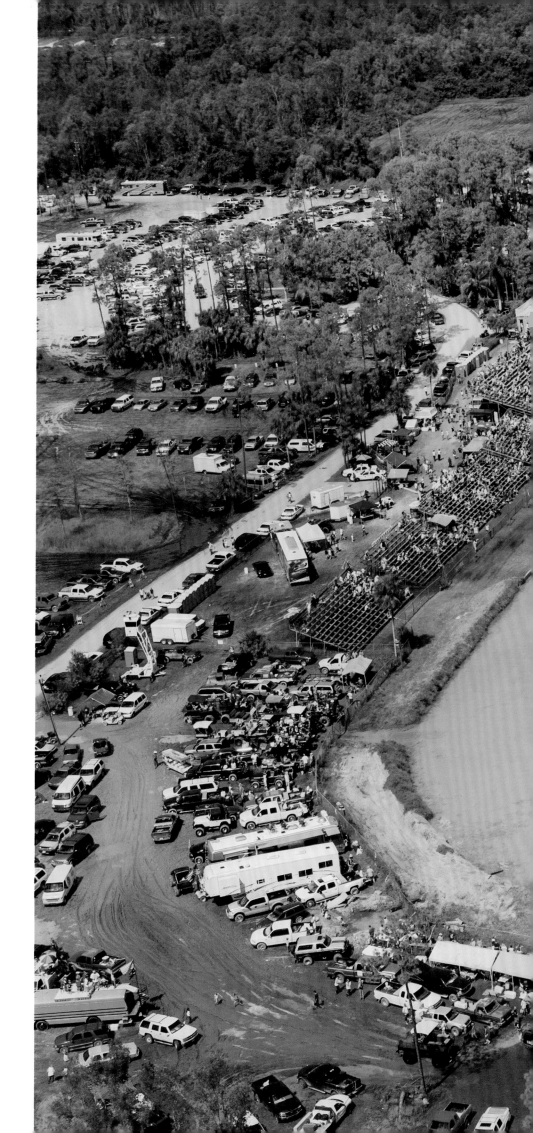

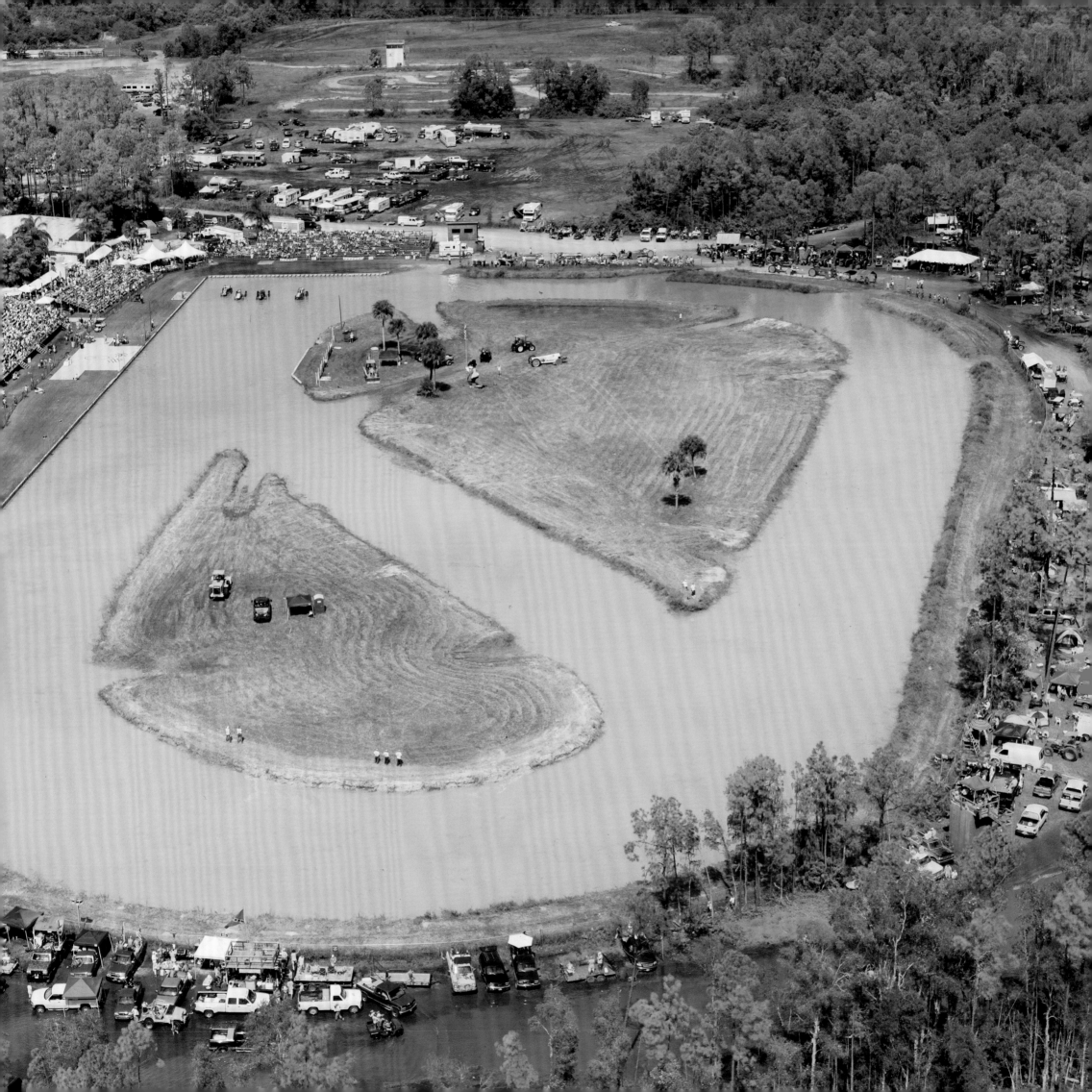

INTRODUCTION
Padgett Powell

My brother's boy, while he was in college, told me, giggling, that he had been assigned to read a story of mine and that he deigned not read it, and when I asked if he had told the professor I was his uncle he said, giggling more, No. I adduced him disinterested in me and all of my affairs, as Mark Twain said of Cooper's Indian. Then, with notice of his graduation, came this handwritten note:

> Dear Uncle Padgett,
>
> Thank you for inspiring me to achieve great things outside of the life I was born into. Even though I grew up with a vendetta against the South, your writing helped me see the interesting possibilities and subtleties contained within it, and the power of storytelling.
>
> I'm very excited for the future, and hope to see you again soon.
>
> Love, Perry

I sent him a check for $500 to help with the future.

I sense in Malcolm Lightner's quest to chronicle the racing of the swamp buggy something of Perry Powell's realization that the repudiated can deserve another look. Perhaps in Malcolm Lightner's case the repudiation is softer, perhaps is merely an estrangement, effected by his parents' divorce when he was four and his subsequent removal from his father's side of the family, a family that pursued, among other alien-seeming delights, stock-car racing, which ran hand-in-hand (the tracks were at one time adjacent) with racing these weird buggies through mud. And there was another drawback to this lost, rough world: a great uncle on his mother's side of the family was R.L. Walker, Swamp Buggy King in '51 and '52 in his other-worldly jeep Flying Saucer.

Whatever the mechanism or forces in his return to Naples, he has brought with it a capacity to see the interesting possibilities and subtleties contained within the place he left as a child. And that place certainly can be construed as the South and aspects of it that lower the register.

By which arcane, useless phrase I would mean this: next to the Florida Sports Park where these races are held is a gated development called Aventine of Naples. No one at these races is going to be going into Aventine of Naples, and no one wants to. They have they own.

When Malcolm Lightner first shows me the spectacle of these people and these races, he is curious to know my take on them, possibly even a bit apprehensive. "Refined nutbarism," I tell him.

"Is that a word?"

"It is now."

Refined nutbarism applies to much of human endeavor, especially that which extrapolates a practical modest low enterprise like, say, running whiskey in a car a little faster than the law's into immodest high-art legal-alcohol-sponsored NASCAR. In the case of swamp buggy racing, a Willys jeep on fat tires (some of the first ones were from WWII bombers, the big goofy ballooney tires that needed to be soft) good for creeping through a swamp in order to shoot something to eat is extrapolated into a water dragster on wheels as tall as a man and thin as his arm. The ancestral vehicle is now known as a woods buggy or a hunt buggy; it has still the huge and very broad tires to stay on top of the mud, it is tall, it wants to go slow. The progeny swamp buggy for racing has tall tires but they are thin enough to cut through the water and get to the mud, or hardpan, through and over which they can run, with speed. The transmutation of the woods buggy to the racing swamp buggy is powered by idleness and the desire to have some fun. Some fun is had, and occasionally some not fun.

There are seven categories of swamp buggy, two of which, at the bottom and the top, seem the most important. The Jeep class, closest to the original vehicle, bobs along, often with nothing visible except its snorkels and the helmet of the driver in a frothing churn of buttery muddy water, between 40 mph and 0 mph (not infrequently stopping altogether in the holes), though they give the impression of moving at about five miles per hour for much of the course. The top-class Pro-Modified looks like a giant Pinewood Derby car that has met Big Daddy Roth; the body resembles an airplane fuselage, the huge wheels almost obscure the tiny driver in the nose, and the thing moves at 50 to 75 mph (record time computes at 111mph but no one seems to think they really go this fast) in a rooster tail of brown spray the size of a doublewide chasing another doublewide. It is a sufficient aberration of sanity that the idea of insanity and the word itself, *insane*, fills the brain looking at it, and the people looking at it are thrilled and want to watch it all day.

When Malcolm Lightner, son *manque*, approaches these people he does not look like he teaches photography in New York, which he does. He looks more like a skateboarder, which he is. He walks softly with a big lens, in a weathered Swamp Buggy Races cap, tennis shoes, stovepipe pants, the great nephew of a famous Swamp Buggy King 60 years ago, and people throw themselves at his camera. He turns his cap around, which they see (he means business), and

starts seeking the Cartier-Bresson Walker-Evans moment, which they don't see. You will see below a photo called *Kamp Feltersnatch* in which two denizens of the races sit on a stump and feign having sex; Malcolm Lightner has known this couple approximately three minutes and he has said nothing to them.

In the other photos Malcolm Lightner has seized the moment or not, a matter that you can see as well as or better than I. Beyond the incomparable *Kamp Feltersnatch* I personally like most two others: *Off Season* and *Bleachers*. These address my notion that enterprises of this sort spring from idleness, and here the idleness is literal and perfect and beautiful. Take these spectral bleachers and fill the air over them with Coppertone and kettle-corn perfume and Skynyrd and rebel flags snapping and fill them with reddening people needing something to distract them from the ordinary day.

When Malcolm Lightner is told that once his father was found beating the hell out of someone outside of a bar called The Anchor, he asks, "Why was he doing that?"

"Because the guy was wearing yellow socks."

Malcolm Lightner says, evenly, "I didn't get that gene." There is something of a chuckle all around at this observation by the prodigal son: *fair enough*.

It will develop, though, that the story is a conflation of two of his father's adventures. The fellow being beaten for wearing yellow socks was at the Royal Castle bar, not the Anchor, and the victim was Malcolm Lightner's father's own best friend Chesley; they tended, when unable to find anyone else to fight, to fight each other, and in this instance Malcolm's father had teased Chesley about his yellow socks until they achieved ignition. In the adventure outside the Anchor bar, Malcolm's father witnessed a man forcing a woman into a car—claiming the woman was his wife, the woman claiming she was not—and rescued her by pulling the man out of the car and beating the hell out of him.

Silliness in the one escapade, chivalry in the other—alas, the "interesting possibilities and subtleties contained within" my nephew's and maybe Malcolm Lightner's "vendetta against the South." Either way, Malcolm Lightner is there with his cap turned around and his observation gene and his camera.

For the final races in January 2013 the weather is good and spirits are warm and generous. During the national anthem I ask a robustly not sober fellow next to me if he thinks we'll get a flyover and he has yelled, embracing me, "Maybe a flying lawnmower!" and we see very high up what looks like a small Learjet and someone says, "There

goes John Travolta, that's our flyover," and there's a laugh. We are at the venerable Redneck Stadium, a two-story mobile tower of pressure-treated two-by positioned perfectly at the sharp turn coming out of the diagonal slash in the racecourse. If something good is to happen, it happens here.

And damned if Glen Chesser of the legendary Chesser racing family does not come around in his Pro-Mod rig Dats On (the Chessers worked at a Datsun dealer in the 60s and named their buggies Dats Da One, Dats On, and Dats It in homage to Datson) running very fast because of the shallow water (Glen will later say he was doing 100 mph) and the two inside wheels leave the ground and the huge wheels keep tipping over in what seems to take minutes, and the giant roostertail the size of a two doublewides collapses, and there is the skinny carboat fuselage upside-down in the shallow, suddenly quiet water, looking a lot like it looks rightside-up except it is not moving and there is a man under it presumably drowning.

The robustly not sober fellow who embraced me and wanted a lawnmower flyover goes under the chainlink fence in a torpedo motion I had seen only once before when my dog did it to have a conversation with another dog who had been talking too much trash through the fence and took the dog into my neighbor's kitchen where I found my neighbors no longer laughing about what Champ had been saying through the fence in fact standing on the kitchen table, the one piece of furniture in the room not broken, asking me to get my dog off Champ please, and Lawnmower is about halfway across the moat when a helmet pops up out of the quiet brown water, and then Glen Chesser pops up out of the quiet brown water, holding his arm the way you do when your arm is broken, so that no one knows, for a good long while, while Glen is attended to on the island in the racecourse, how bad it is. It looks like an EMT convention out there, Glen on the ground surrounded by the EMTs and other staff, and the talk at the Redneck Stadium begins to be about the life-flight helicopter that is going to come, and a big front-loader out on the island goes to scoop up the Porta Potti out there to get it out of the way of the helicopter, and someone up top on the Stadium says, "This is a good thing," to the general chuckling concurrence of everyone who can imagine what a Porta Potti might do in the helicopter wash—and Cindy, who has been mindful of the children Trey, Savannah, and Aurora, whips around and says to the fellow observing that moving the Porta Potti is a good thing, "Would you shut up for five fucking minutes? This is *family*," and Good Thing says, "Certainly," and Cindy says, "*Good*," and Good Thing says, "Our prayers are with you," and everybody shuts the fuck up.

Glen is flown away and the racing resumes. Late in the day the Skynyrd degrades to Nugent and that is my exit point. I went to school with Skynyrd boys and I am not going anywhere with no Nugent. My first instance

of swamp buggy racing has been exceptional and I am done. I don't stay to see Miss Swamp Buggy thrown in the mud.

Glen Chesser is prayed for and he needs it. Malcolm Lightner interviews him later. This is all you need as an intro to Malcolm Lightner's book, I apologize for putting you through all the verbiage up to this point:

What is your occupation?
Golf course mechanic, jack-of-all-trades.

What does it feel like going around the track?
It's a rush, a thrill, you know. Especially when you are out in front winning, not so much when you are losing.

Did you hit a rock as reported?
Buggy went to flipping, I felt my butt coming off the seat, I grabbled a hold of the roll bar and when it flipped, the roll bar hit some rocks in the track, which caused the roll bar to collapse and took my hand with it.

How did you manage to get out from under the buggy?
I crawled out. I was pinned for a little while. I came out between the roll bar and the steering wheel. I realized the mud was deeper and I was able to shove my helmet through it first. Then I was able to crawl out pushing my way through the mud.

When did you realize that your arm was injured?
When I shoved my helmet out. I was laying there telling the lord to please don't let me die like this in front of my children. I tried shoving my helmet in the mud and realized my arm was hurt.

Can you describe your injuries?
Ripped hand practically off, two ligaments hanging. Shortened bone and reattached. Movement in fingers. Too early to tell.

Do you plan to race again?
Depends on arm. Surely like to.

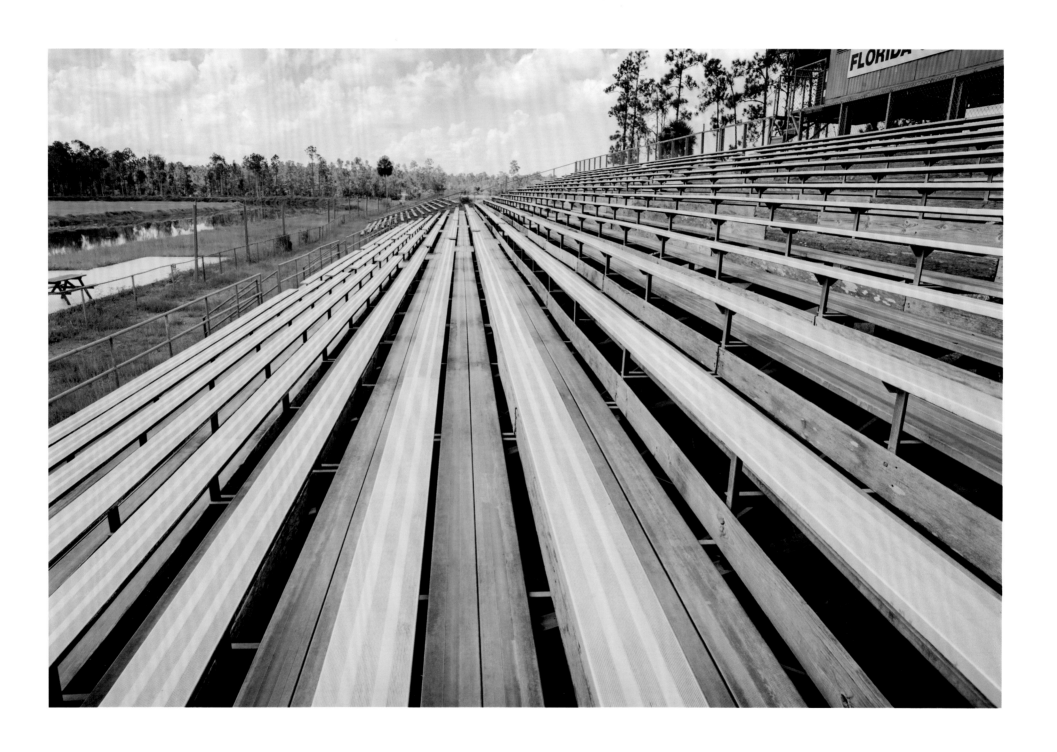

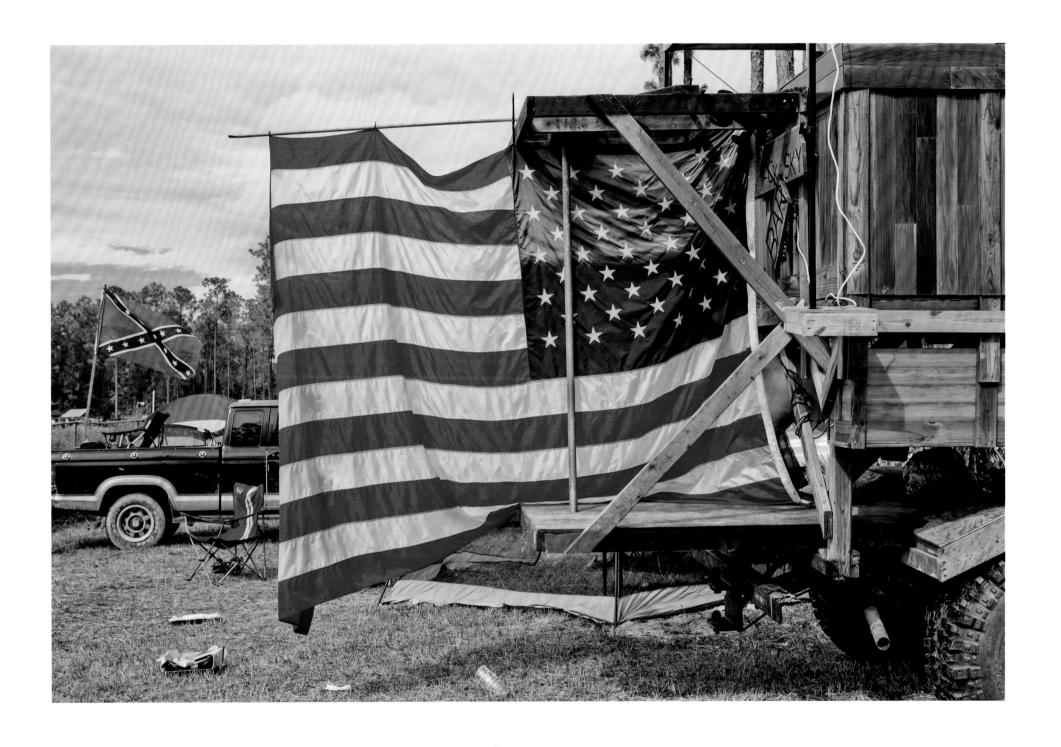

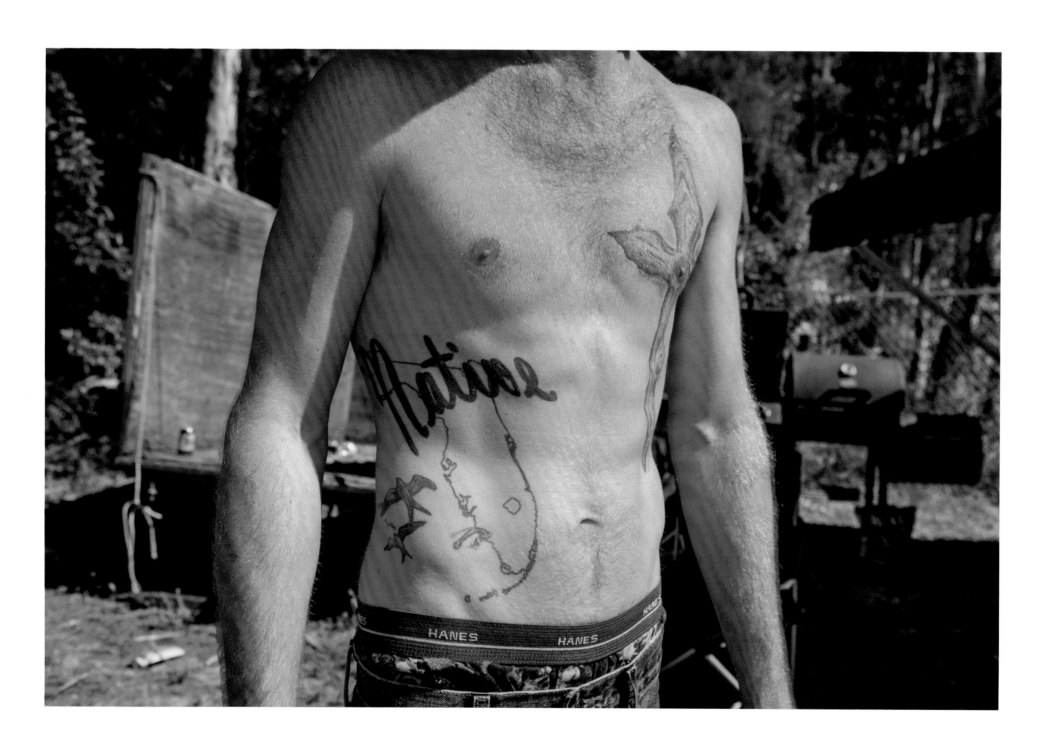

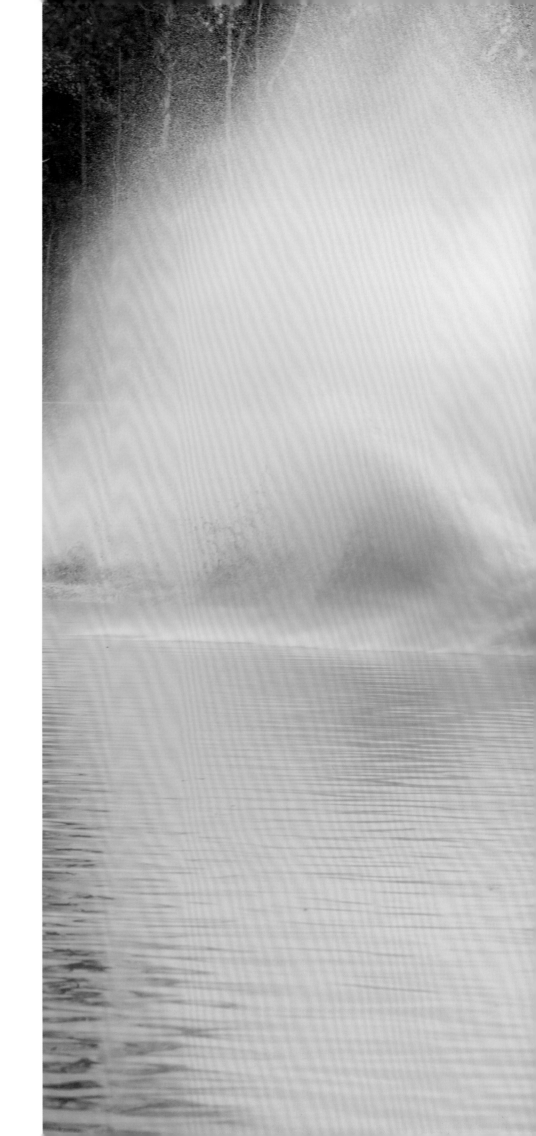

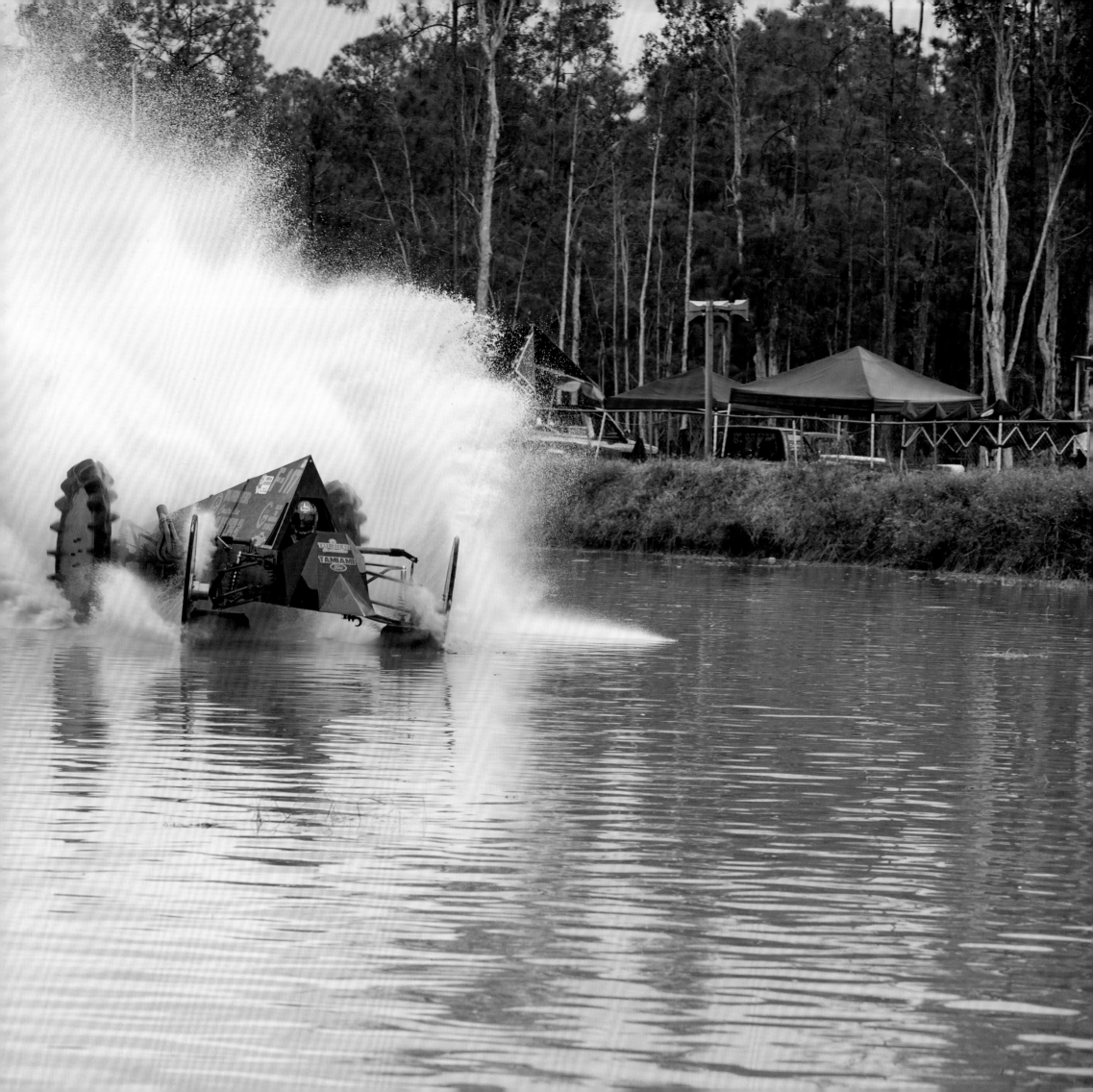

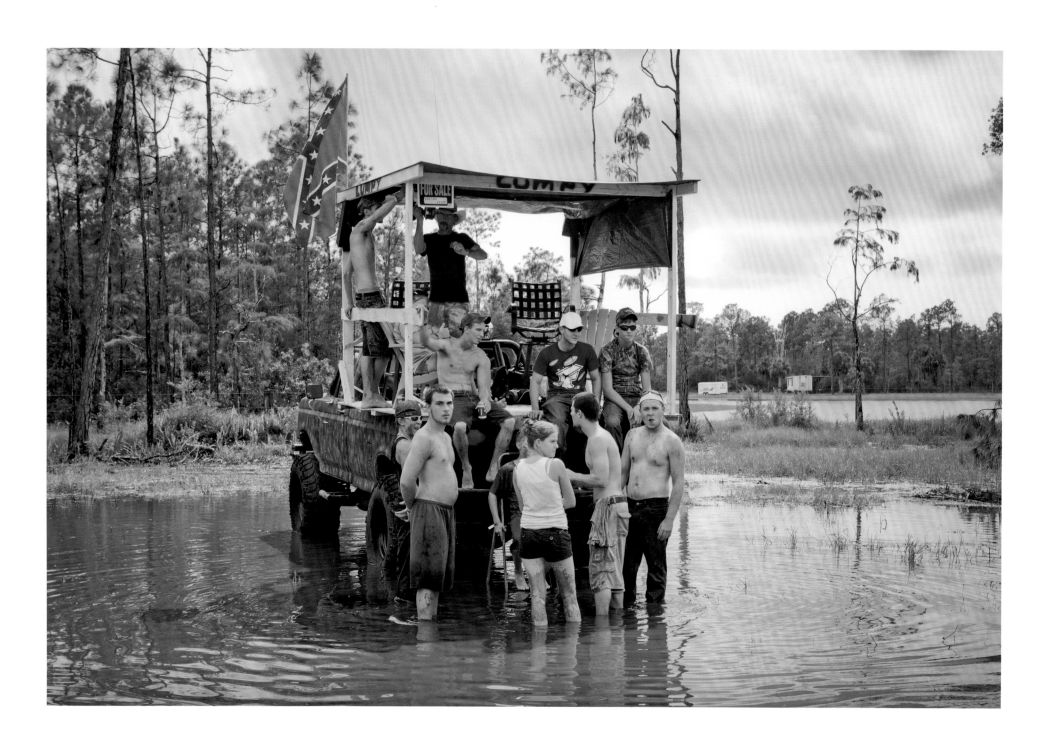

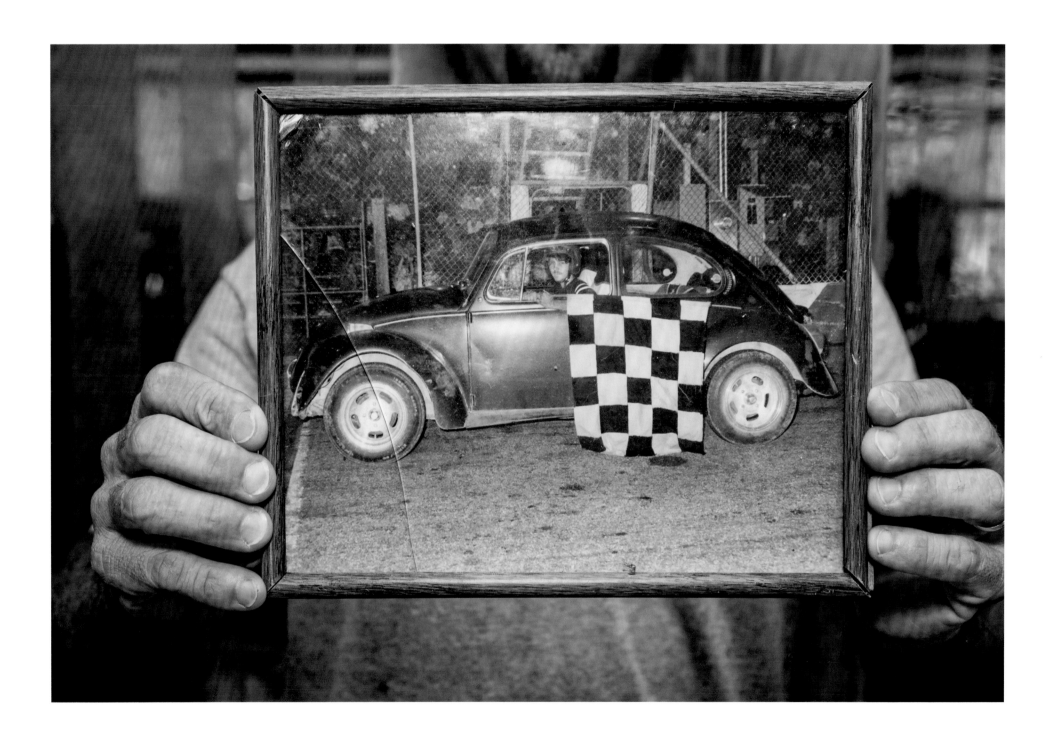

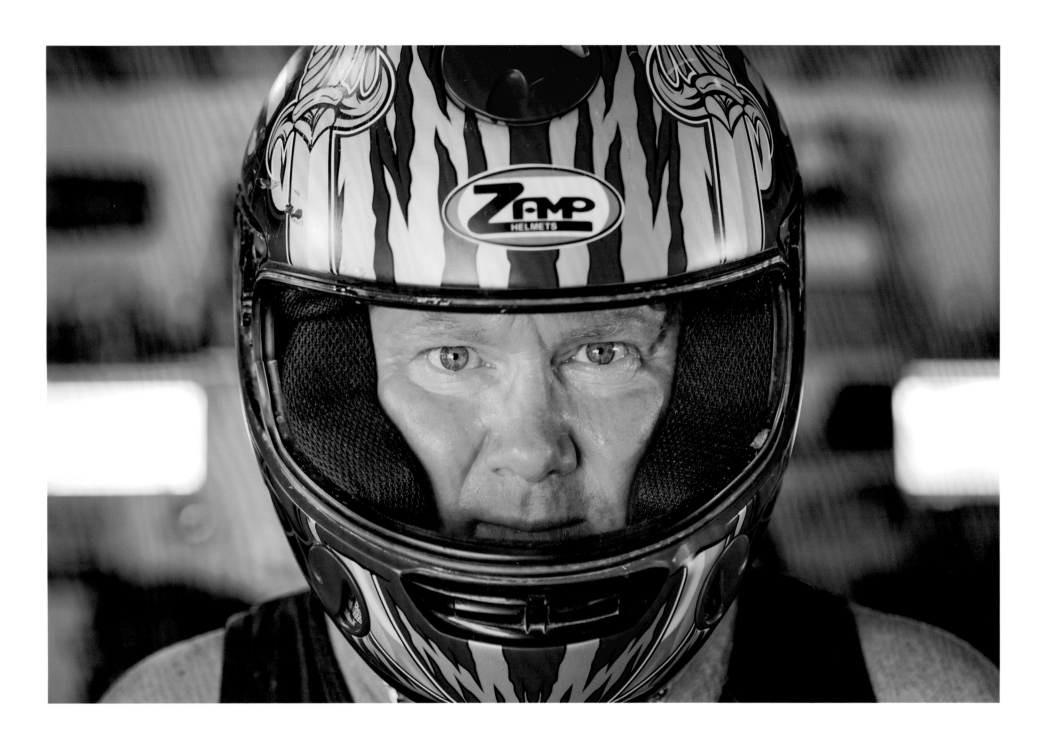

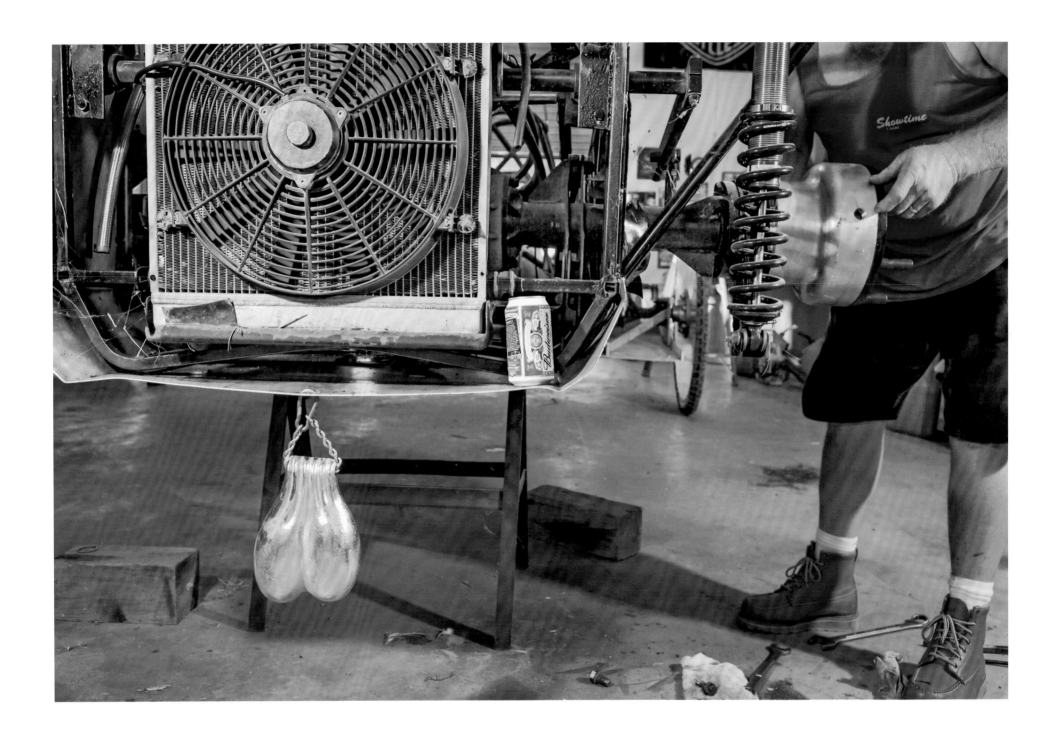

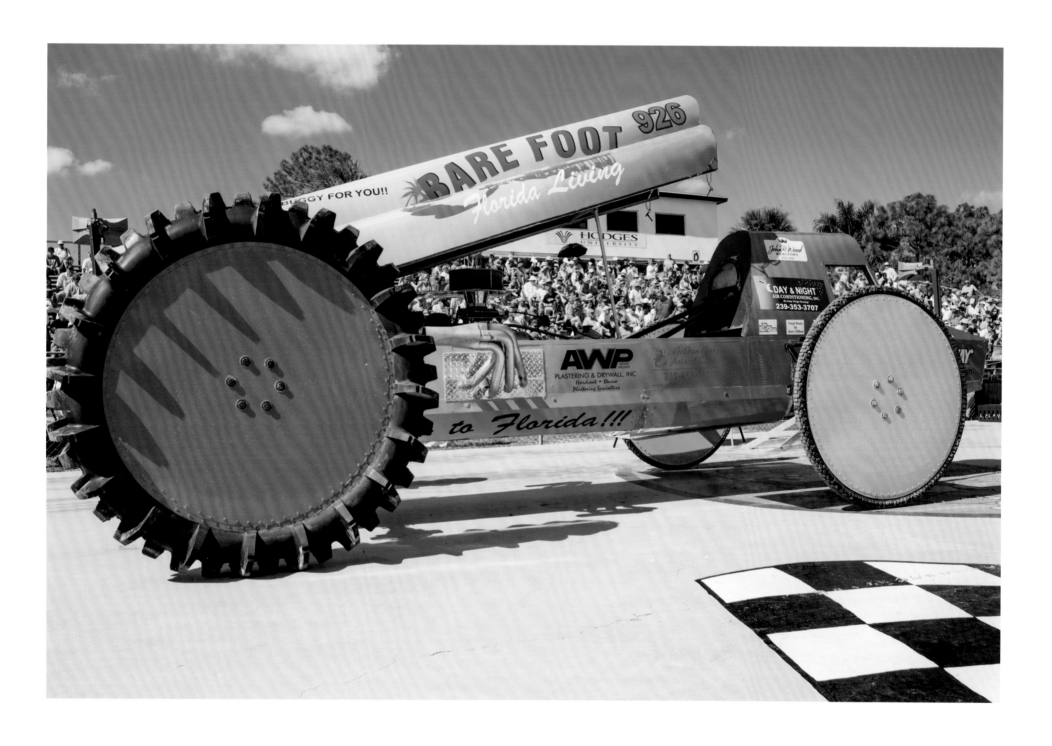

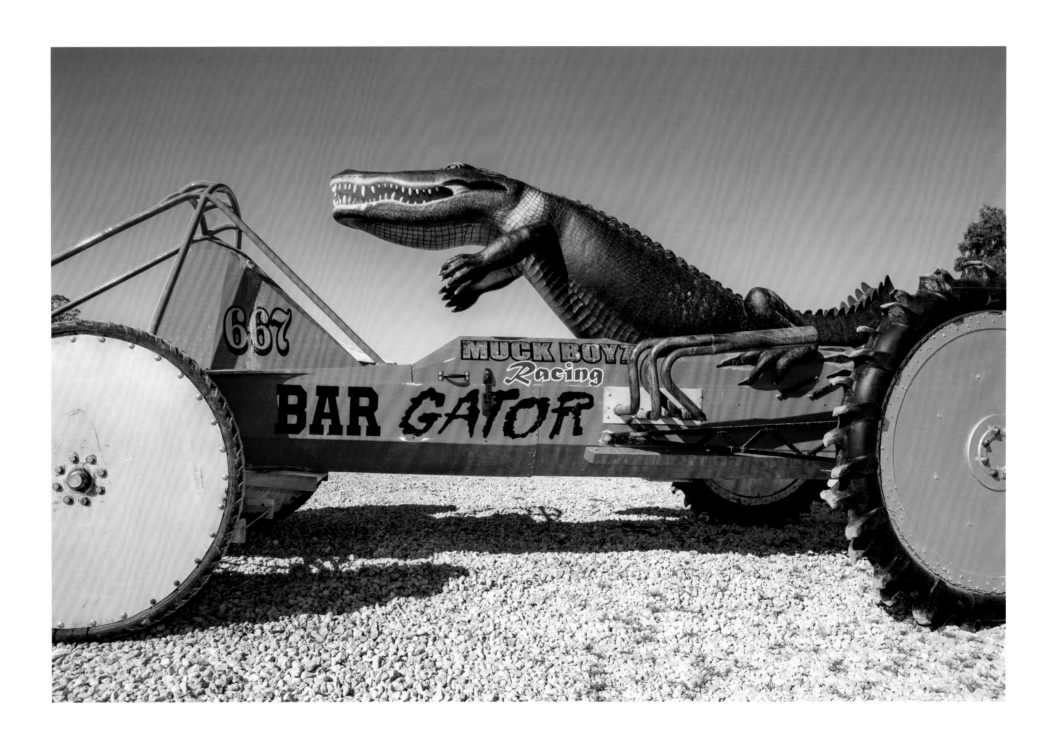

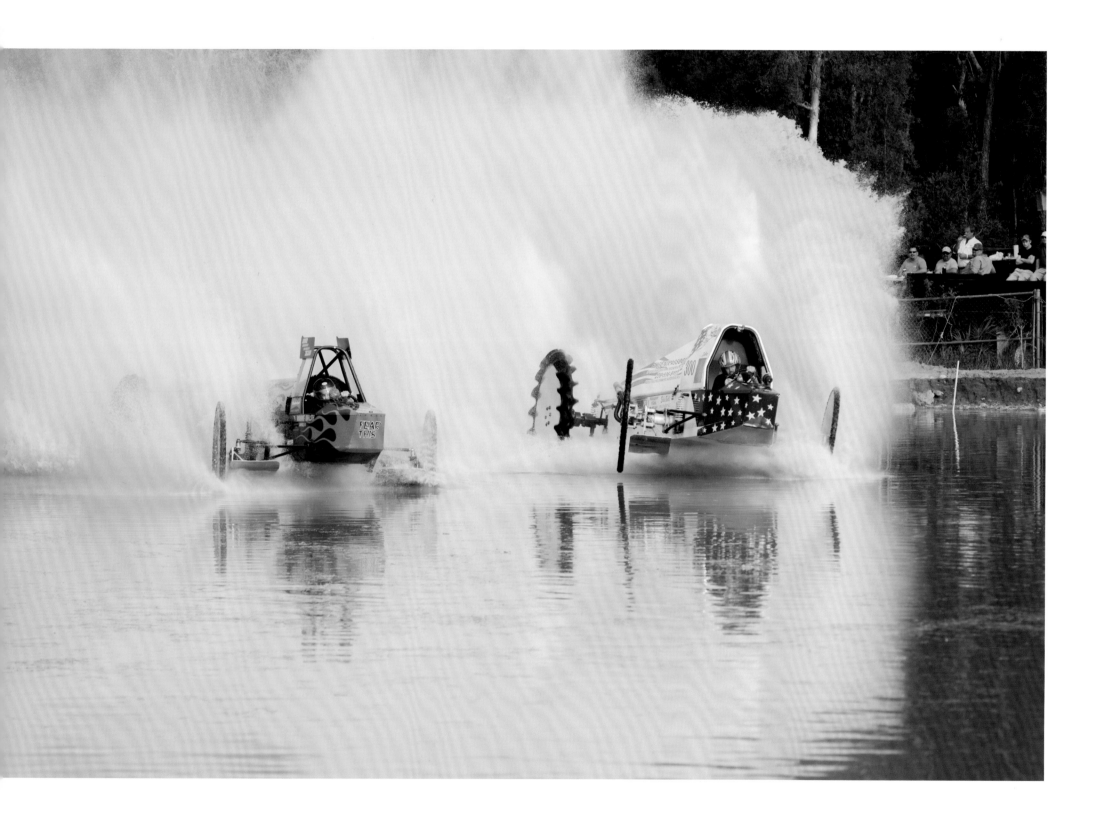

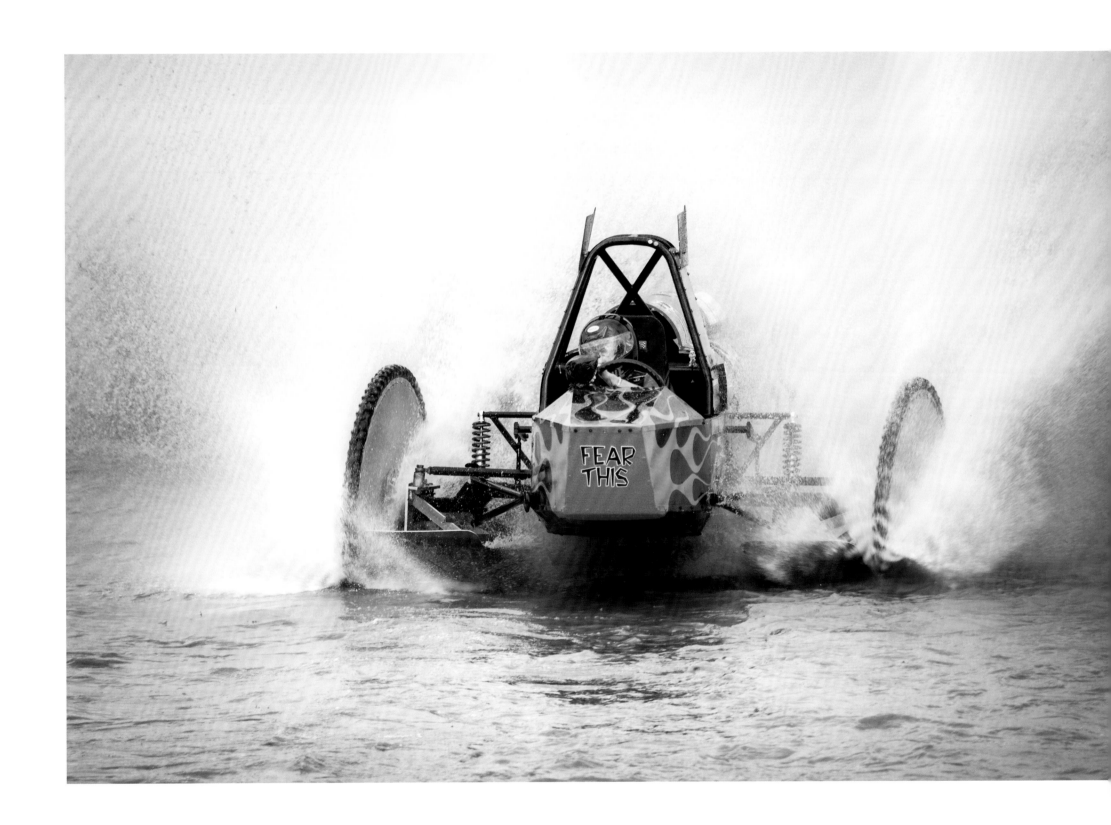

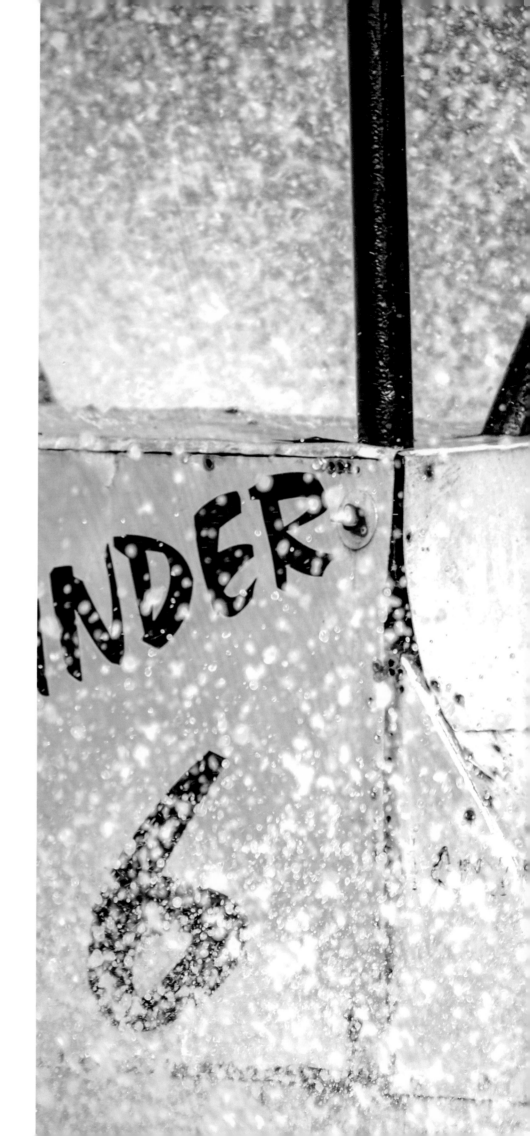

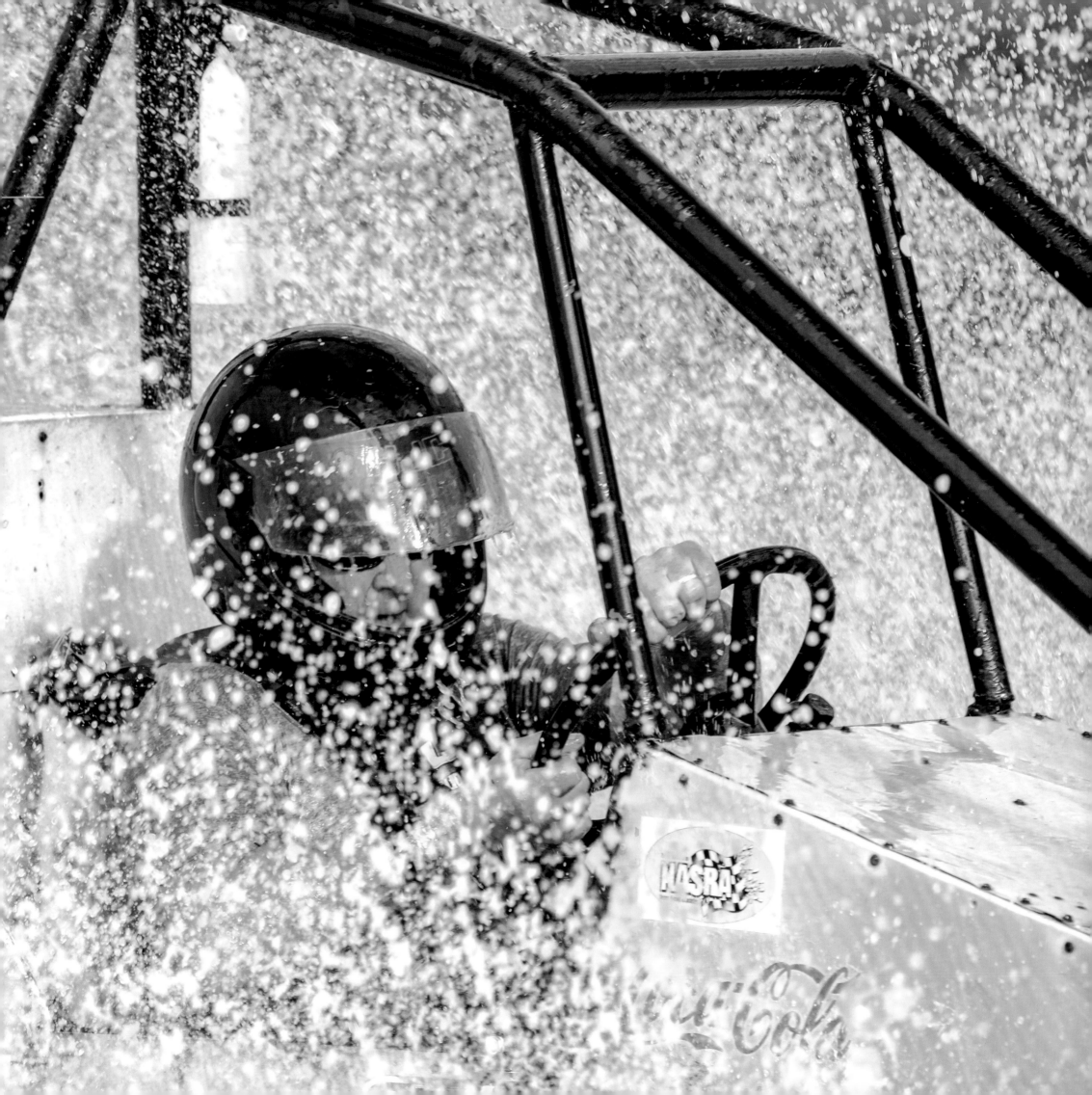

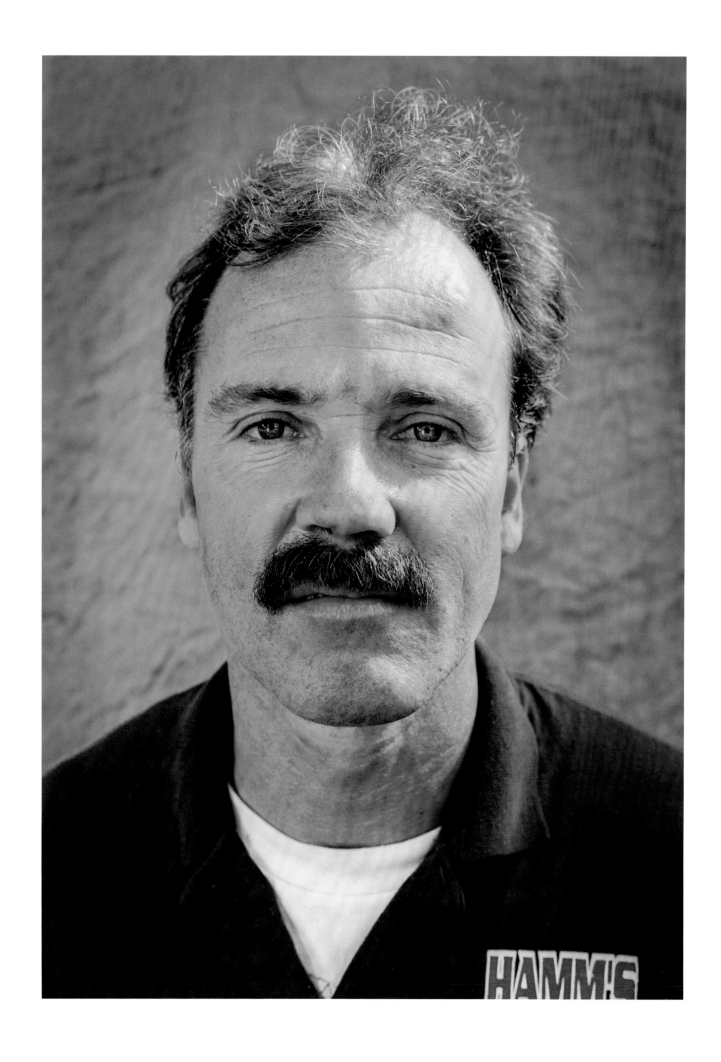

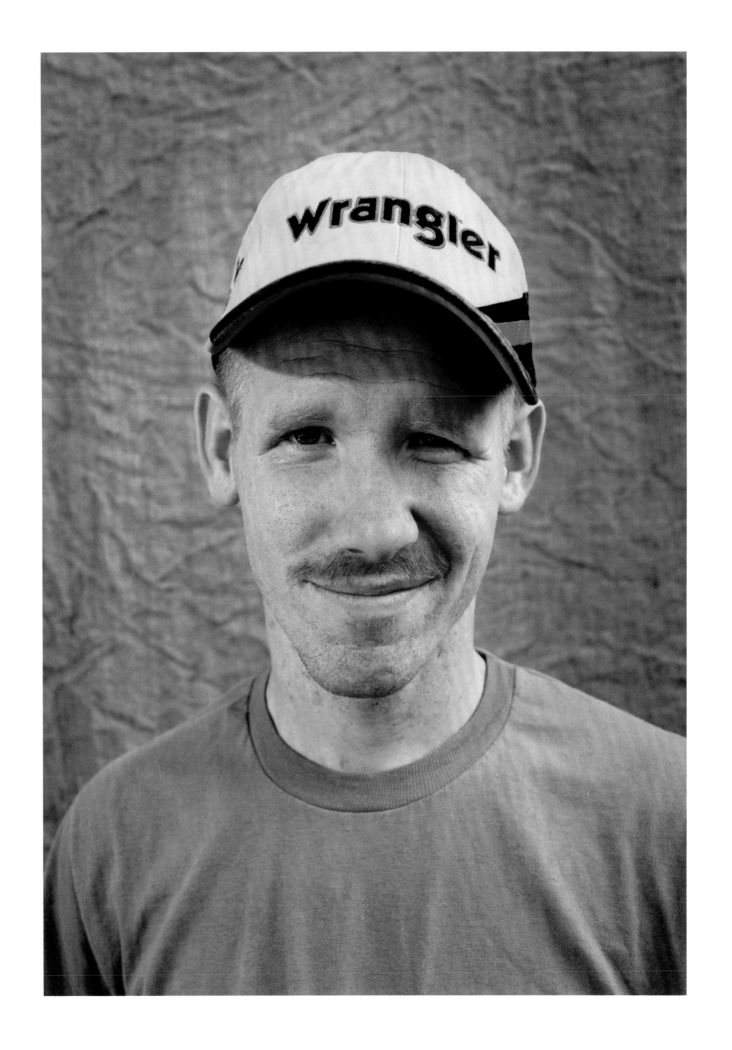

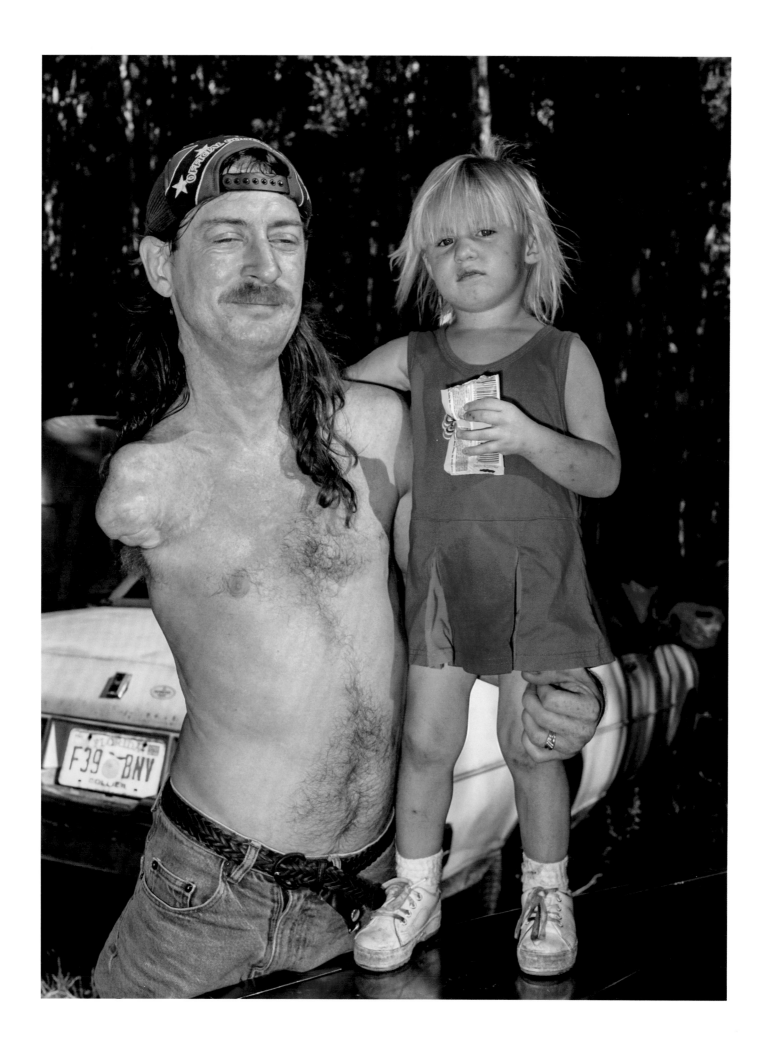

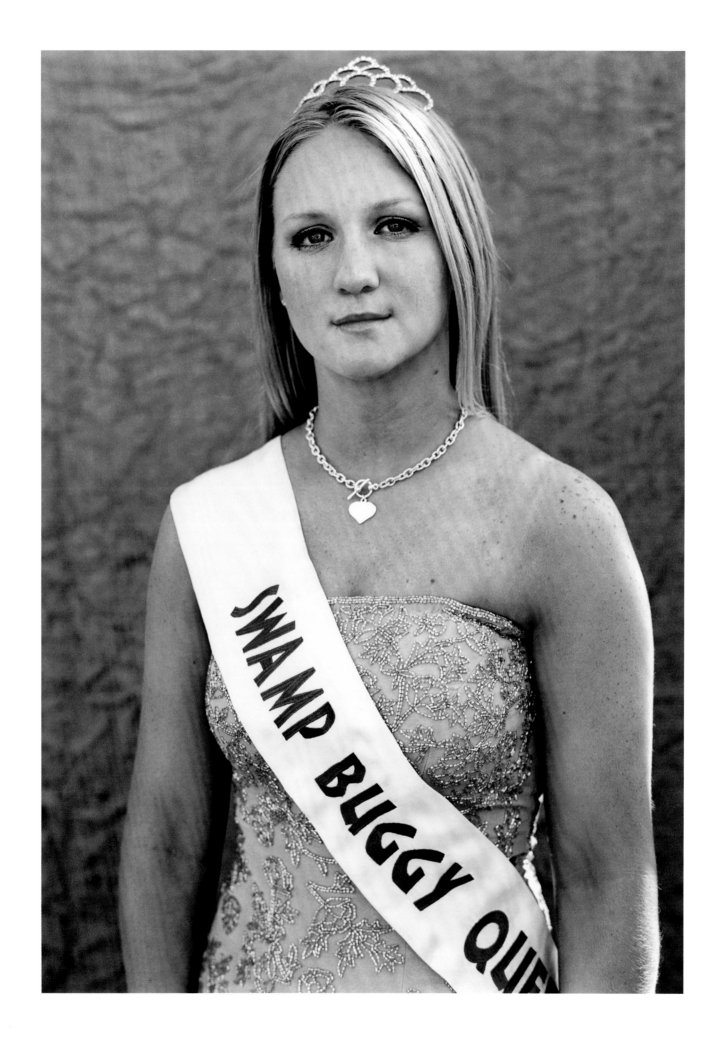

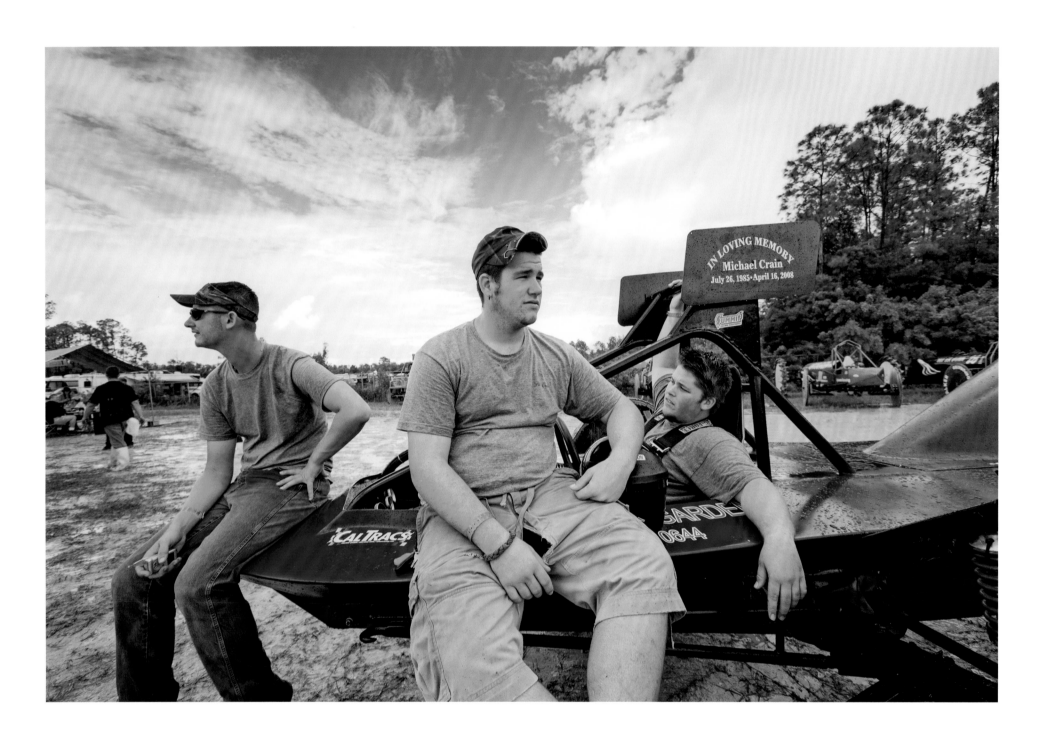

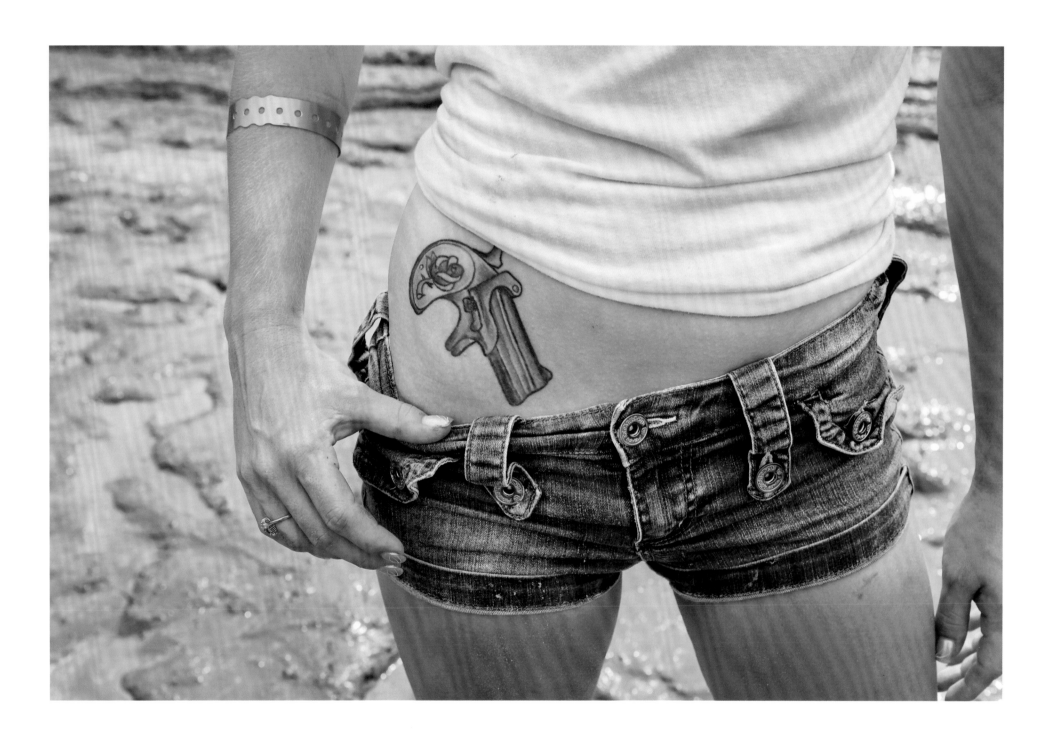

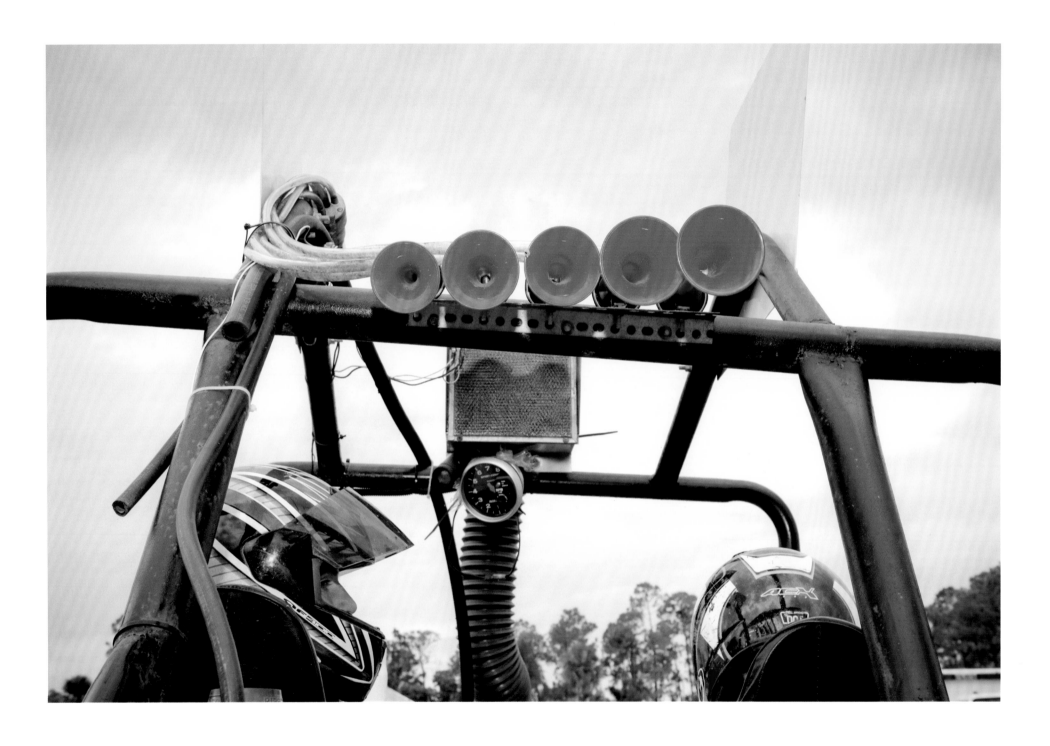

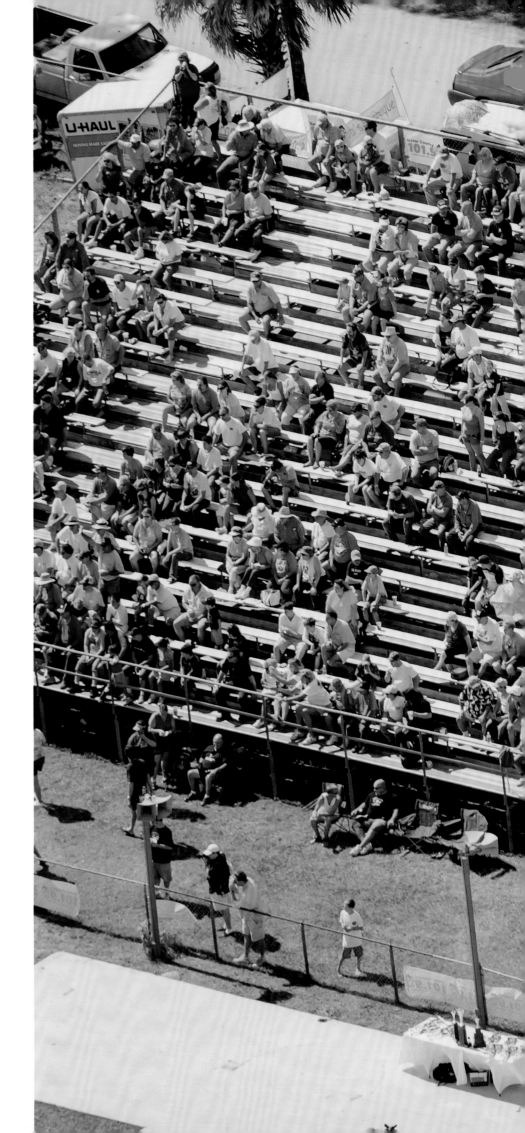

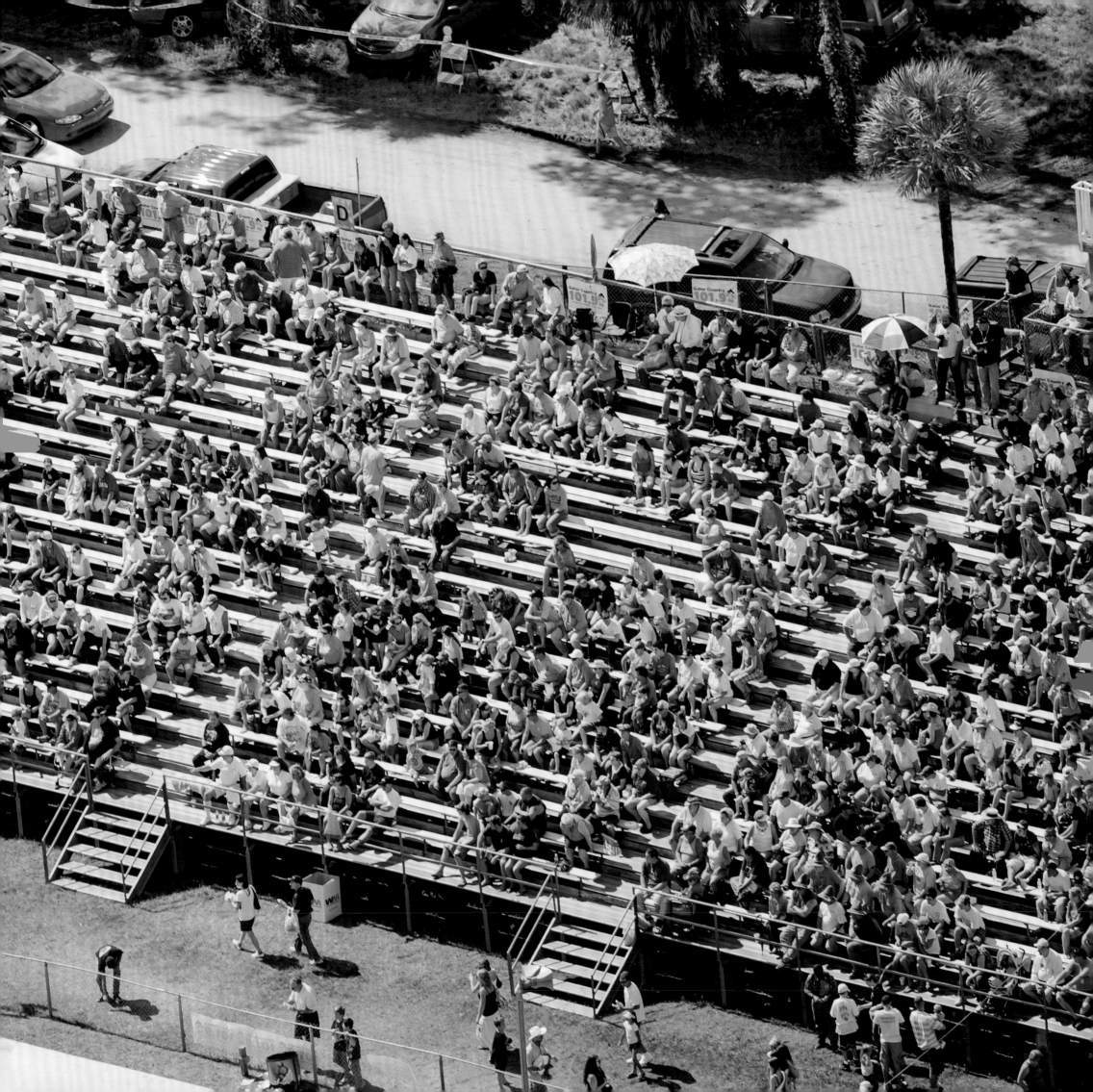

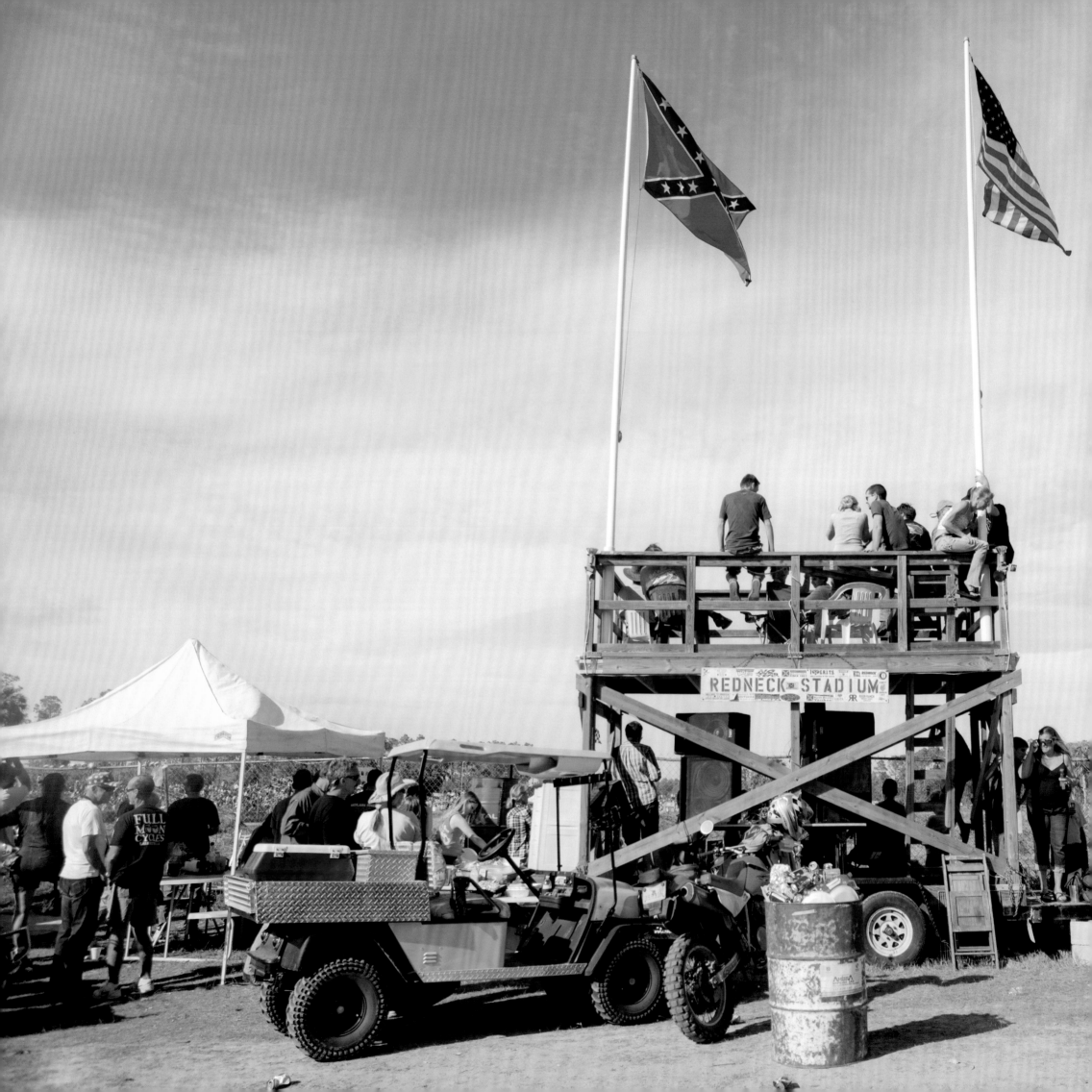

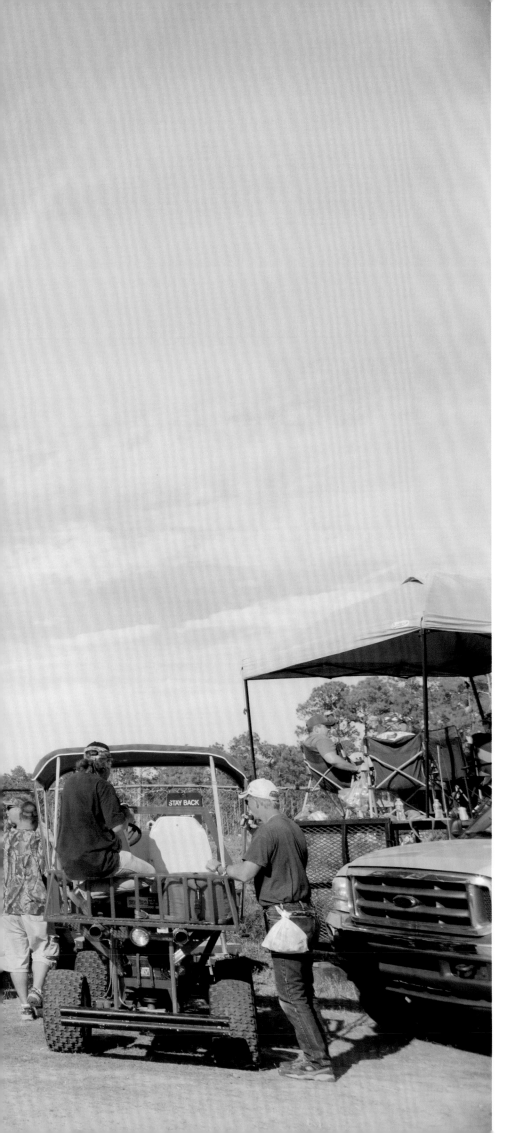

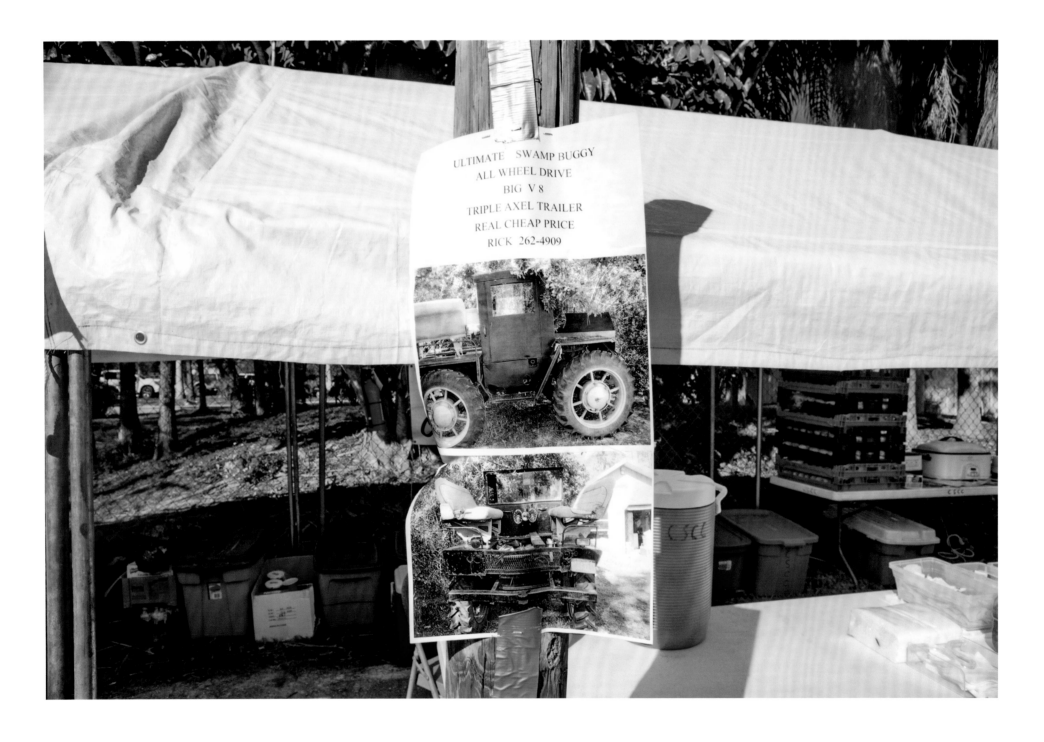

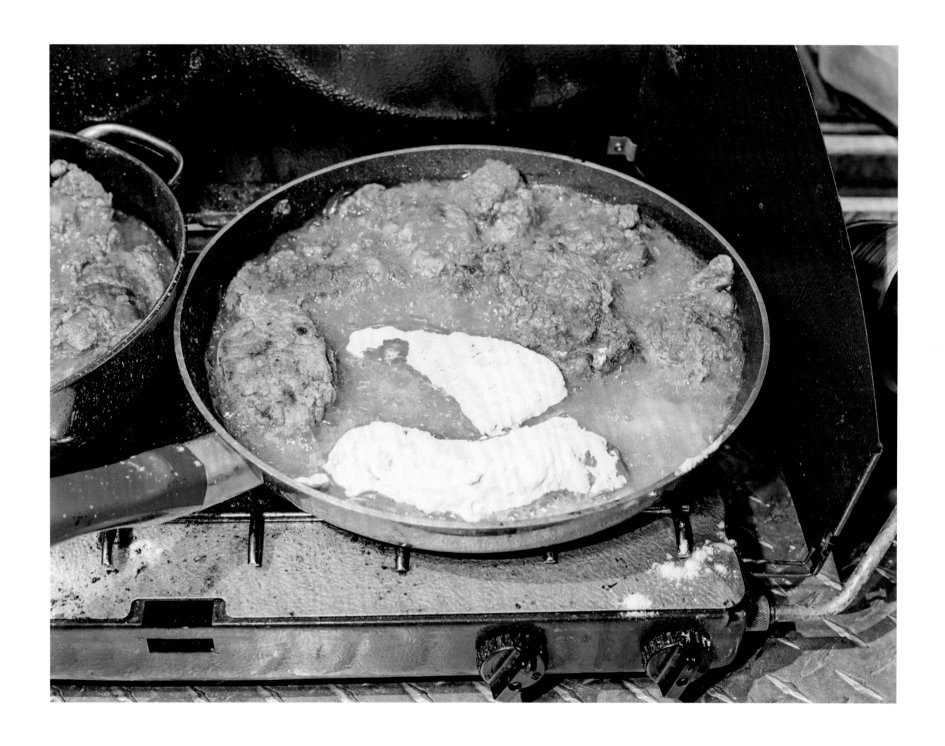

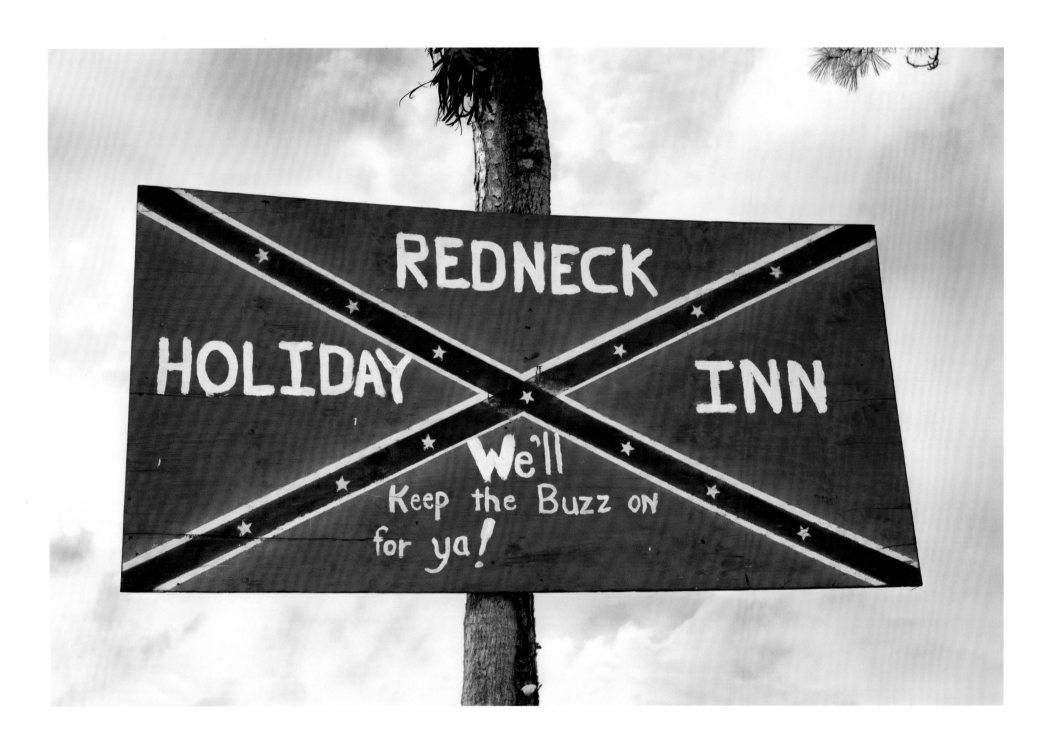

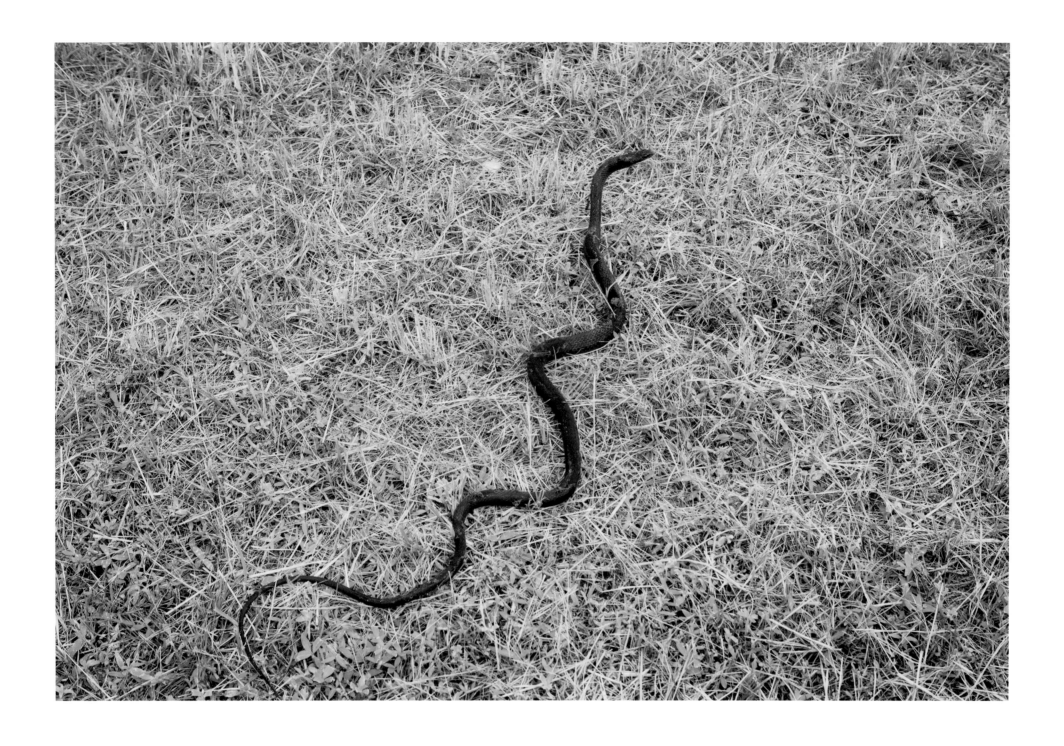

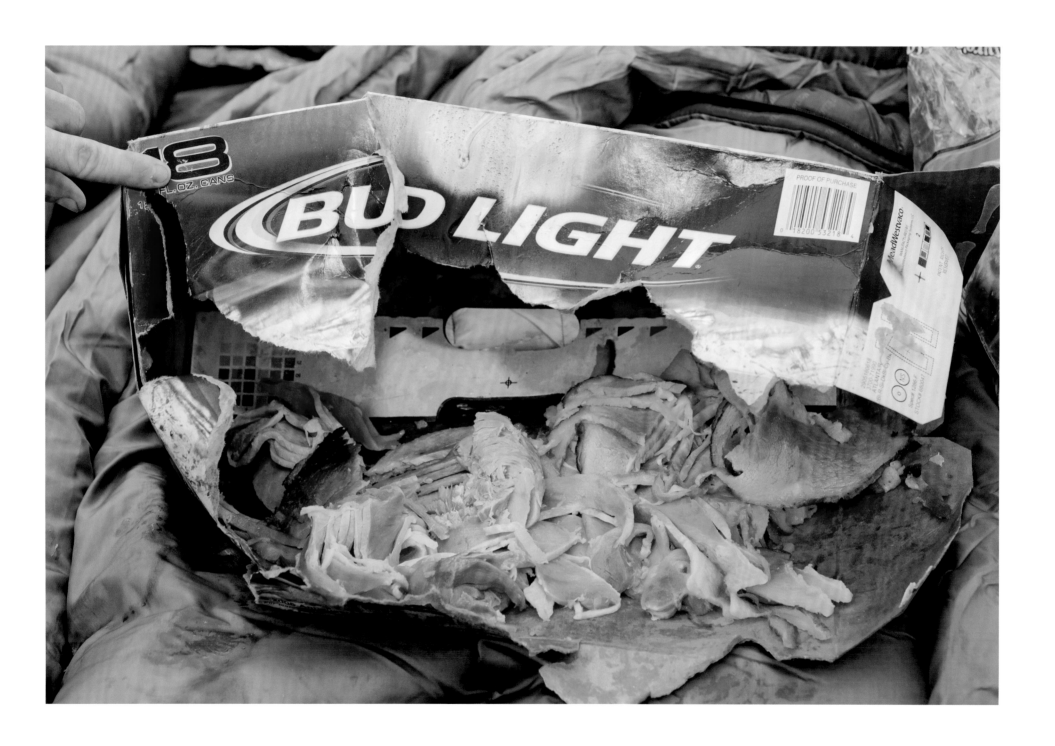

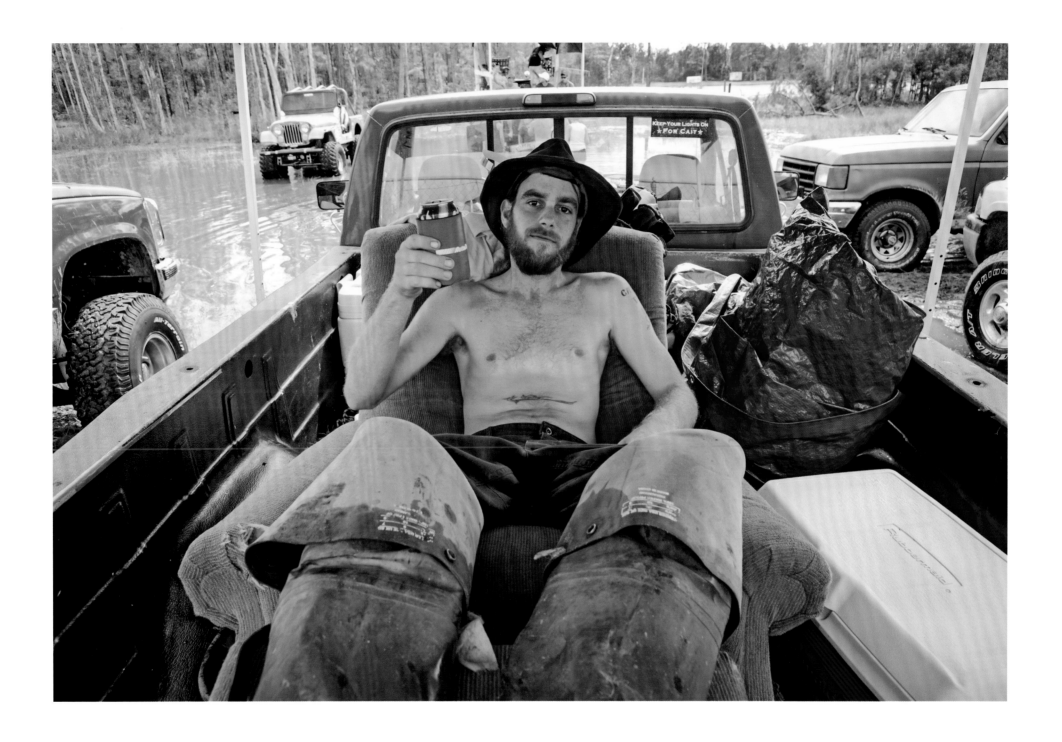

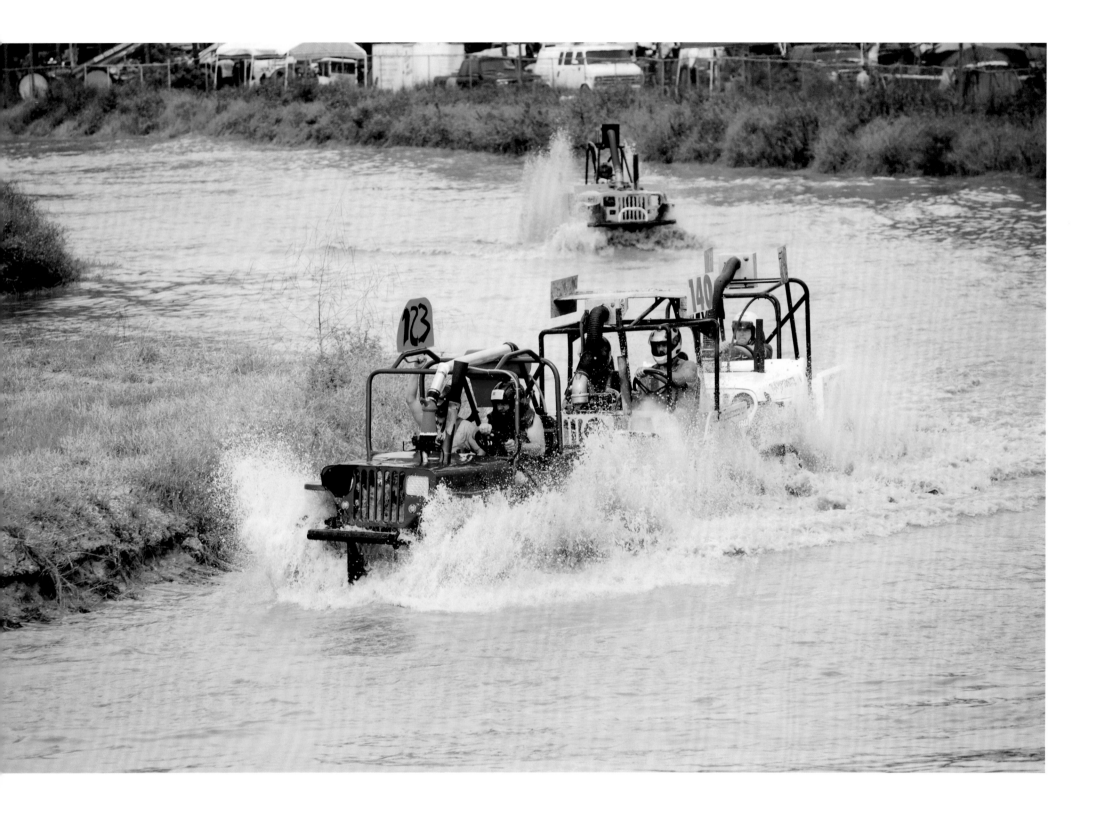

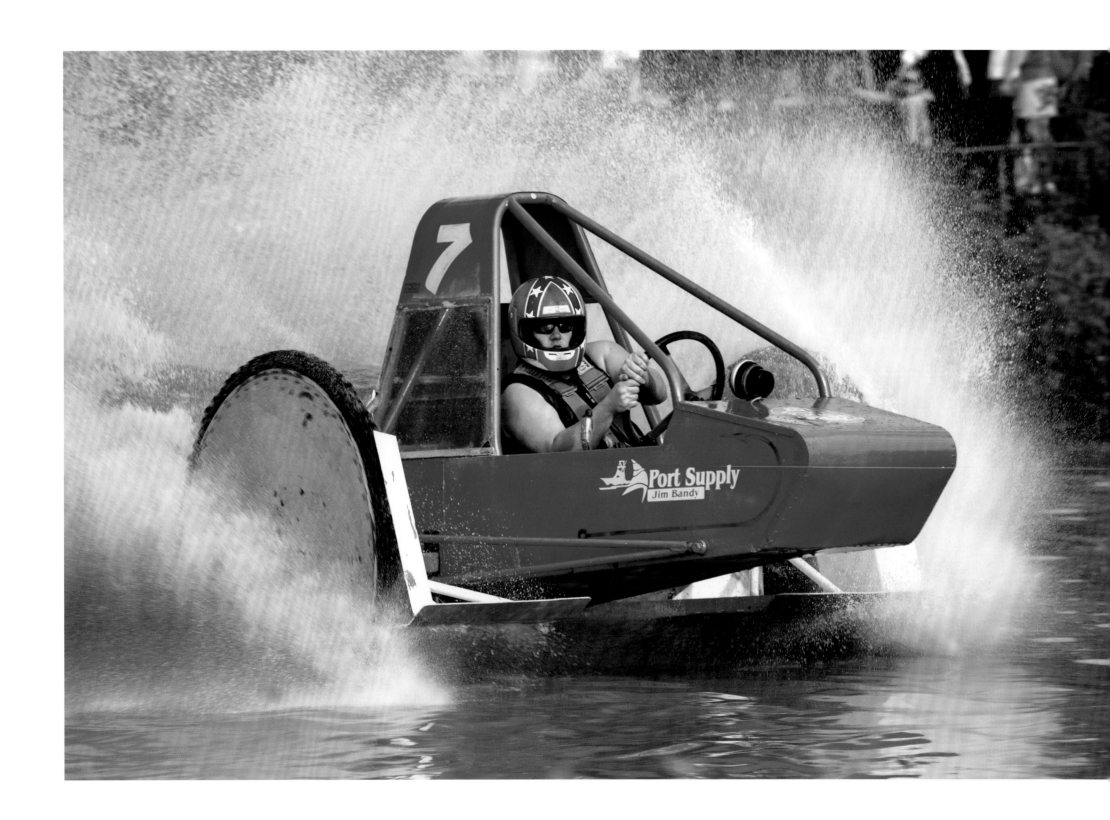

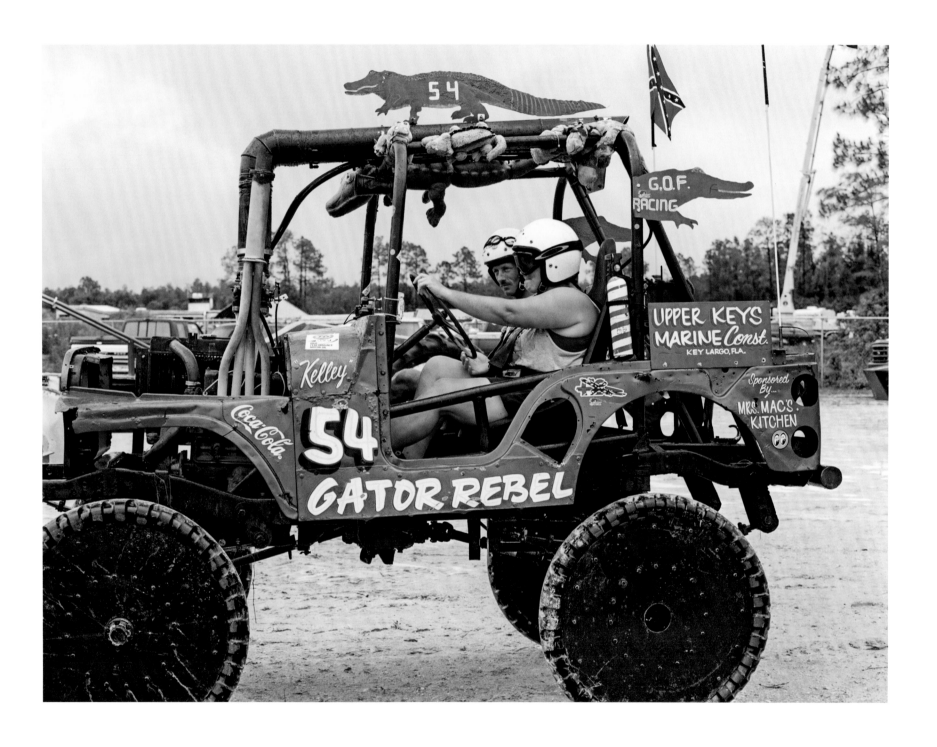

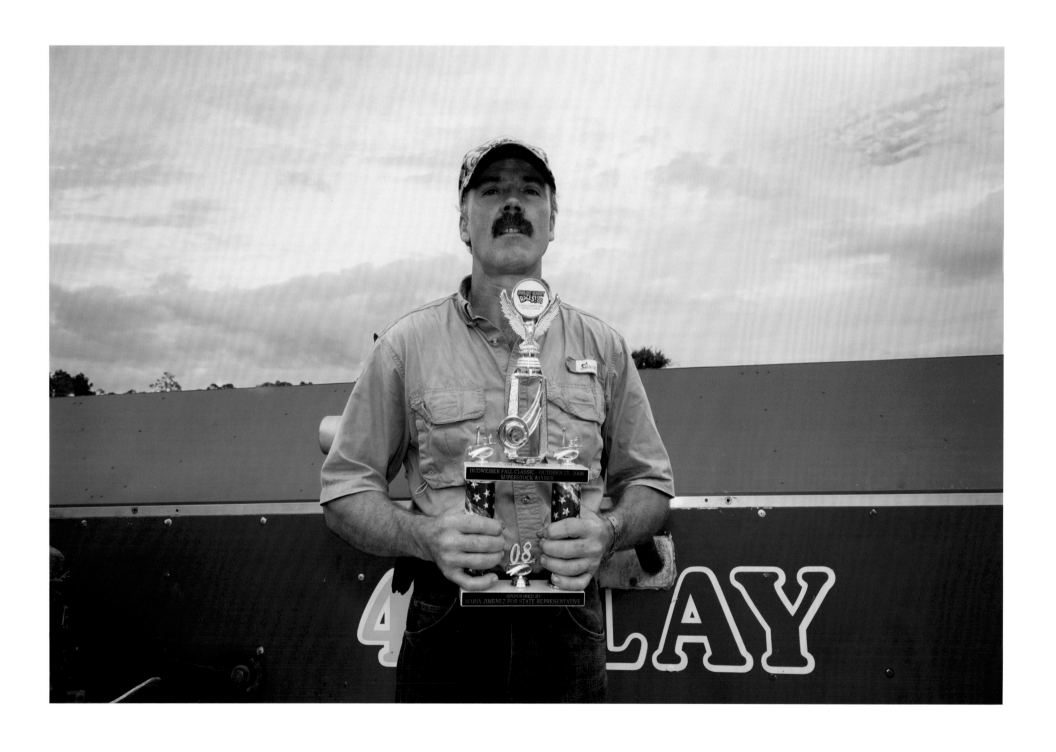

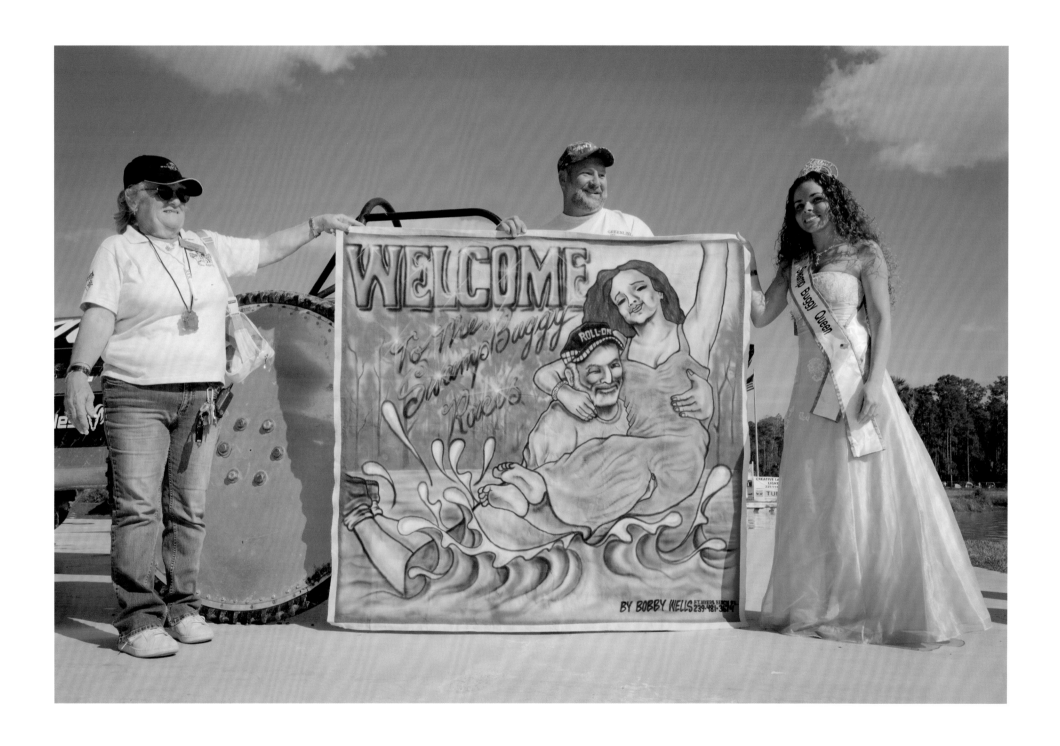

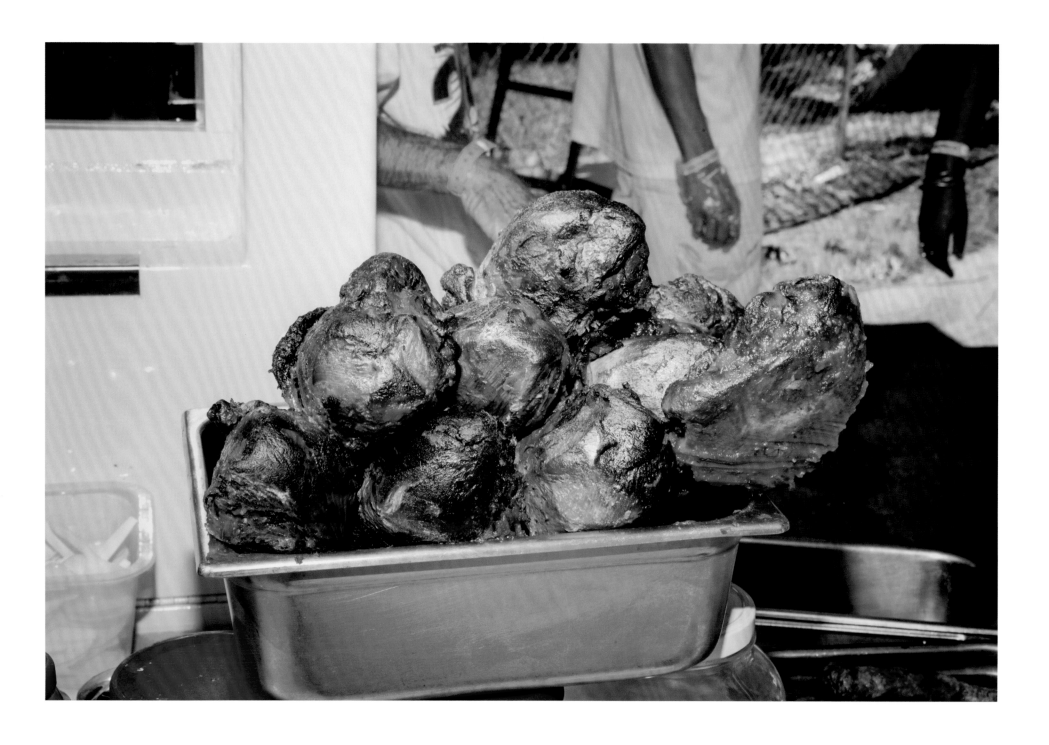

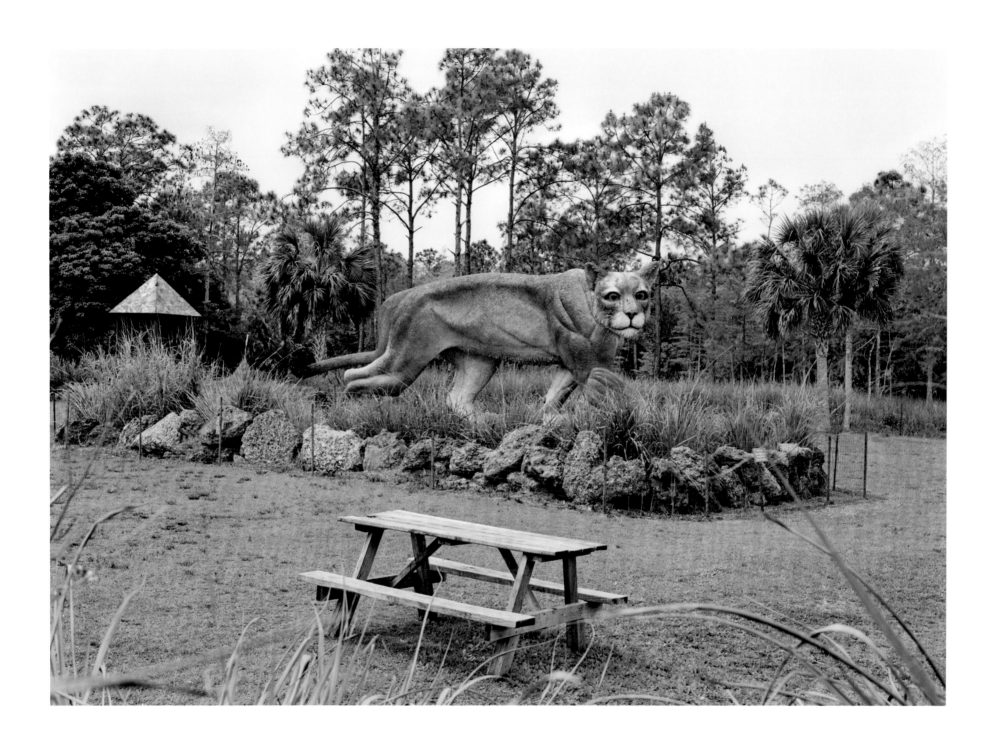

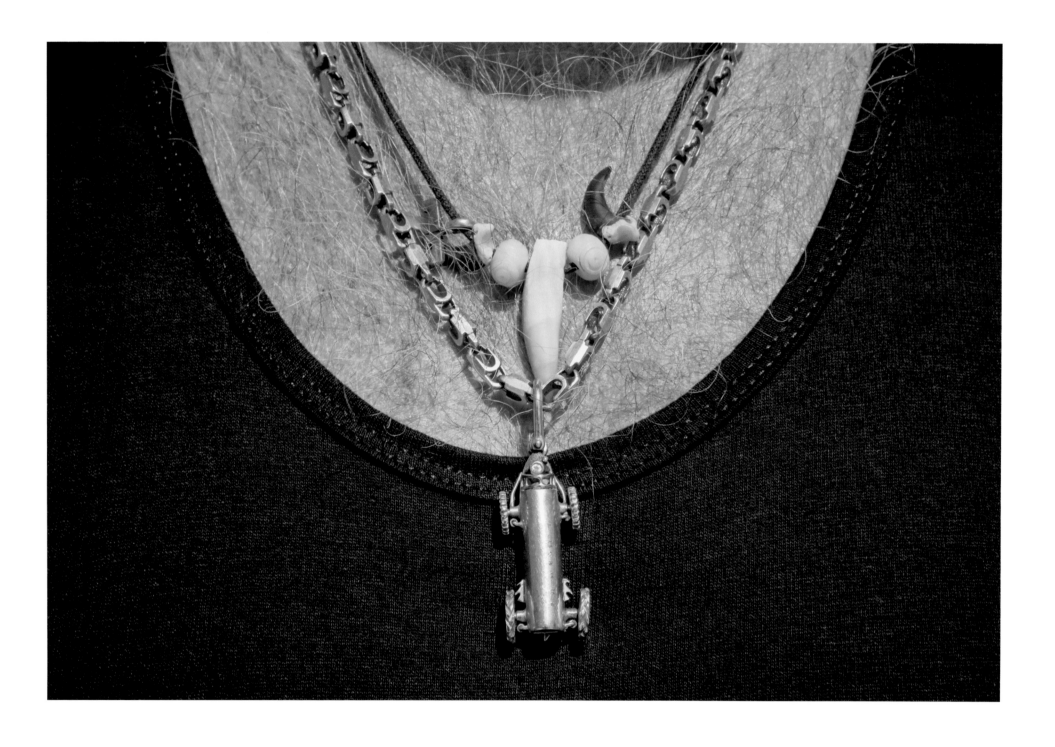

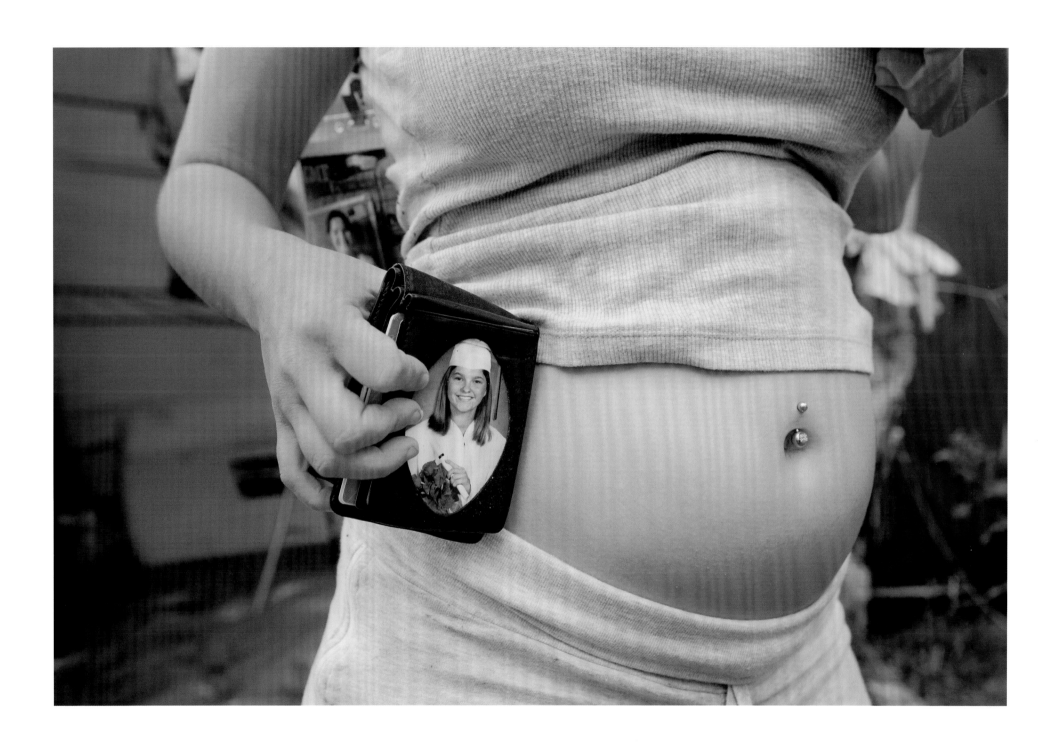

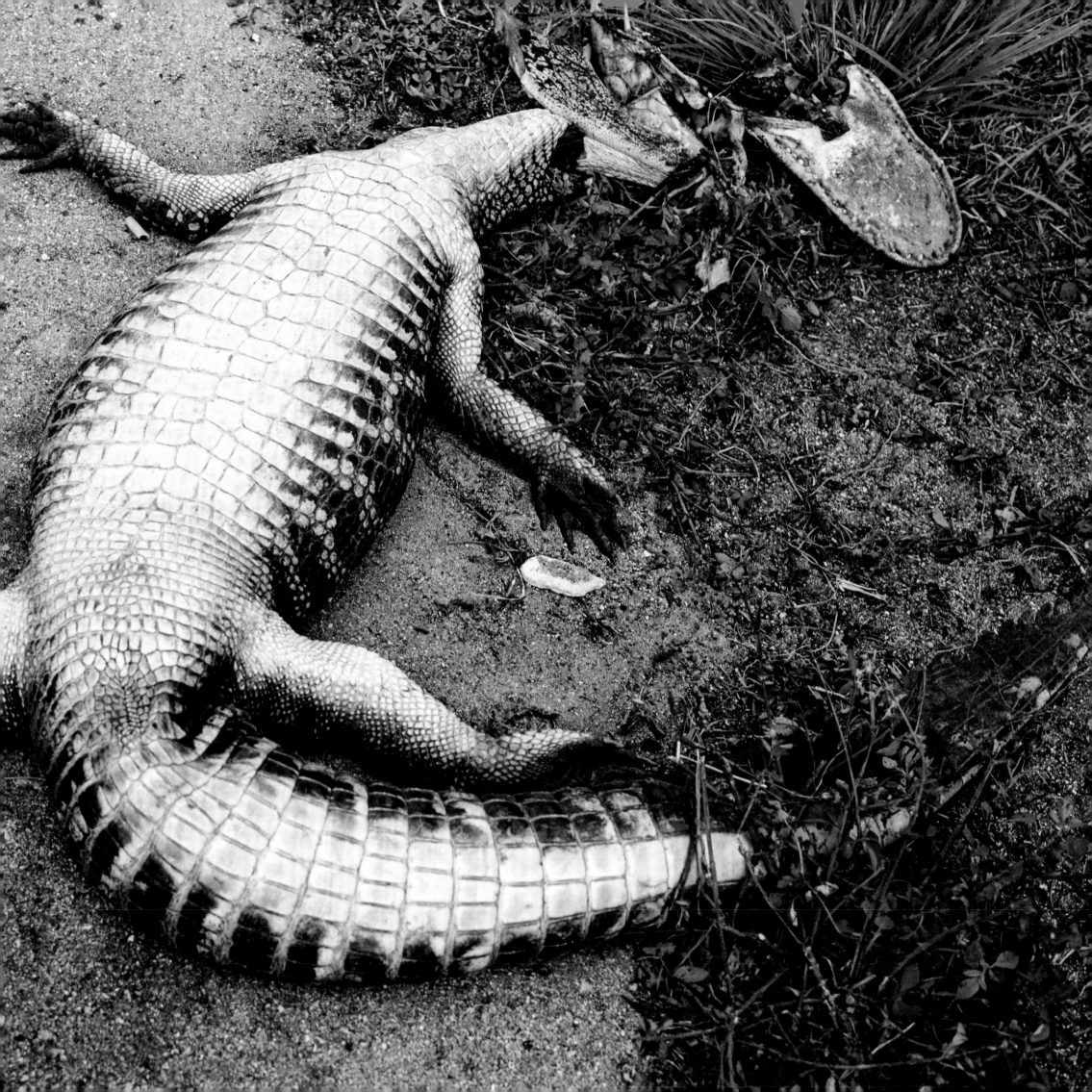

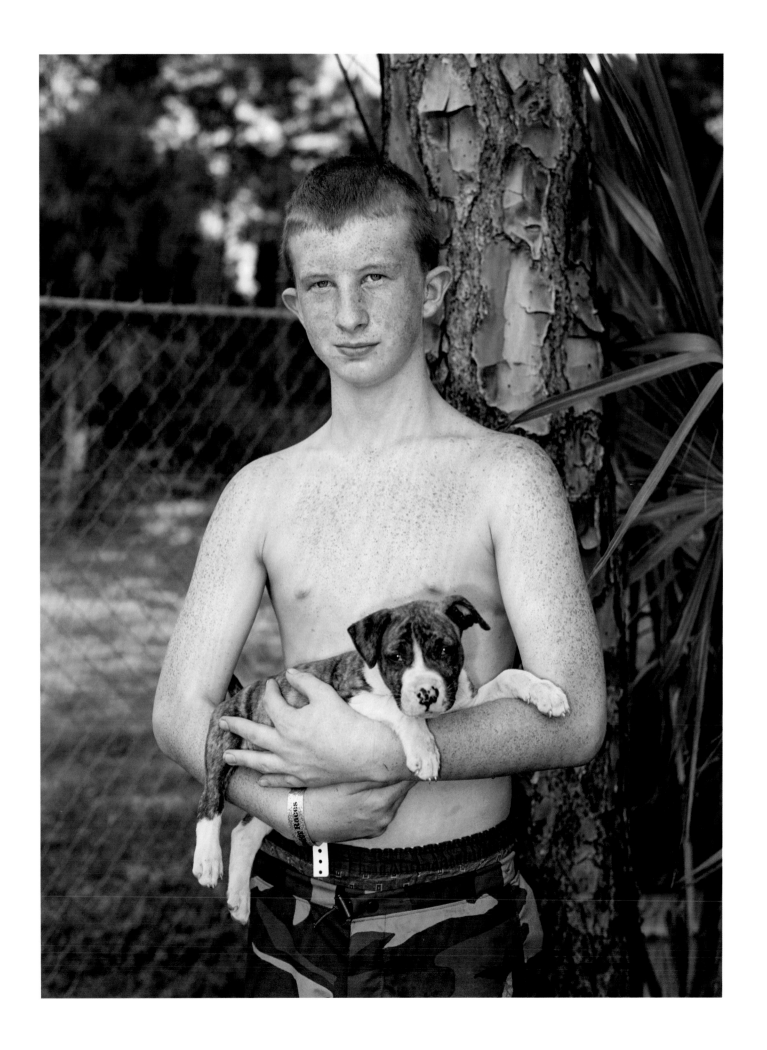

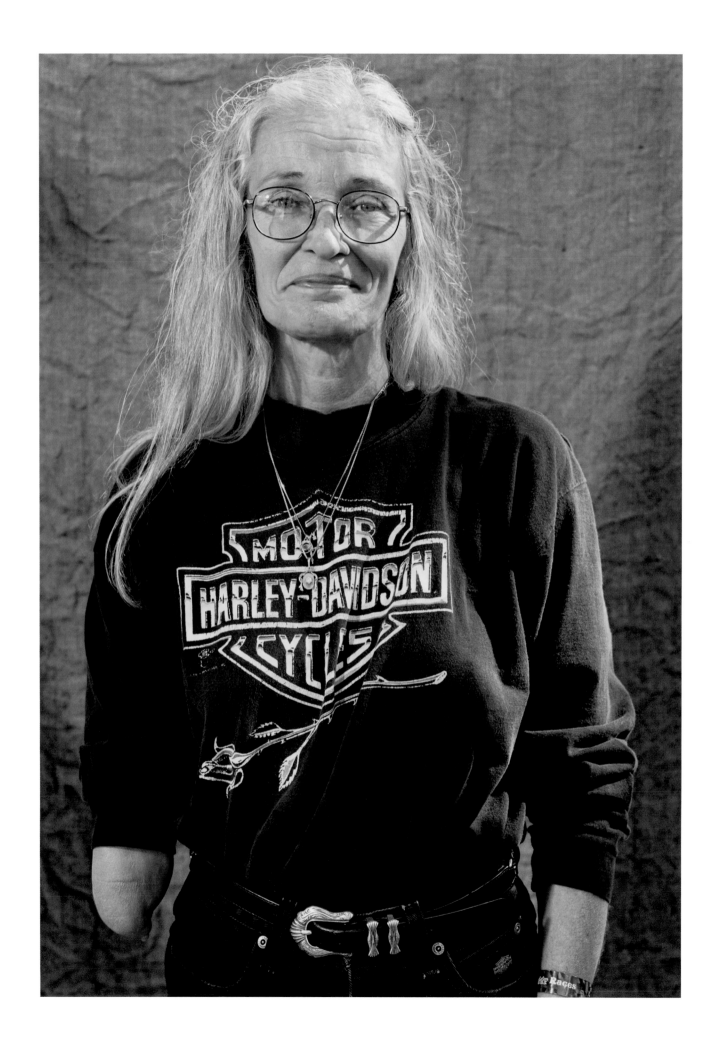

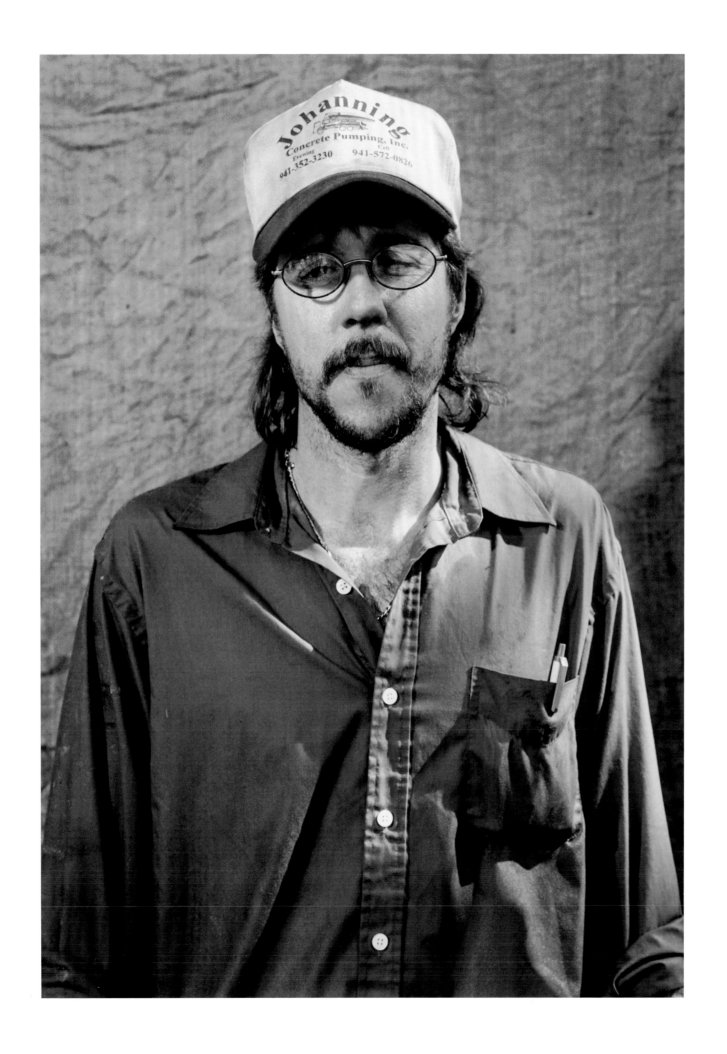

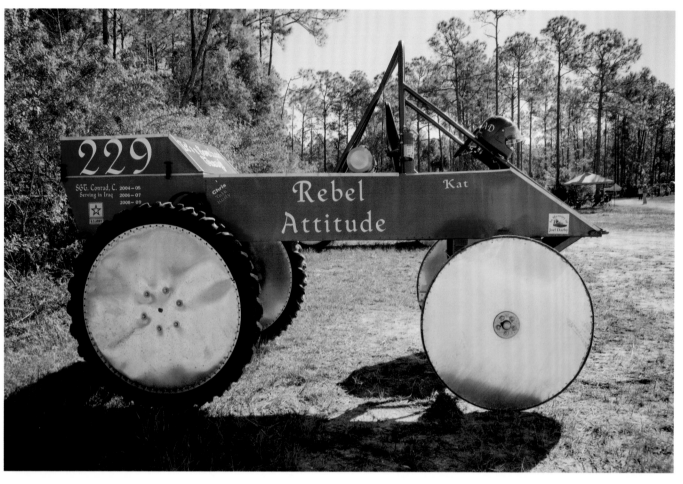

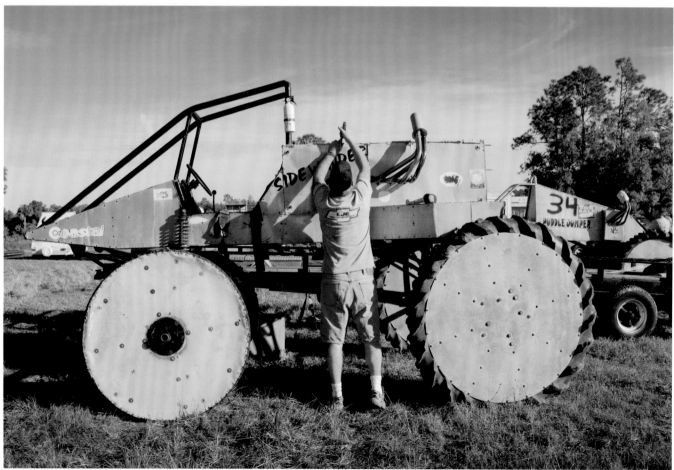

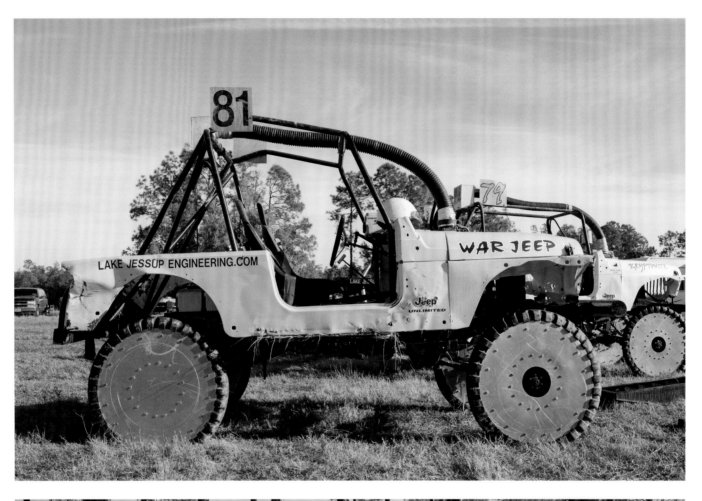

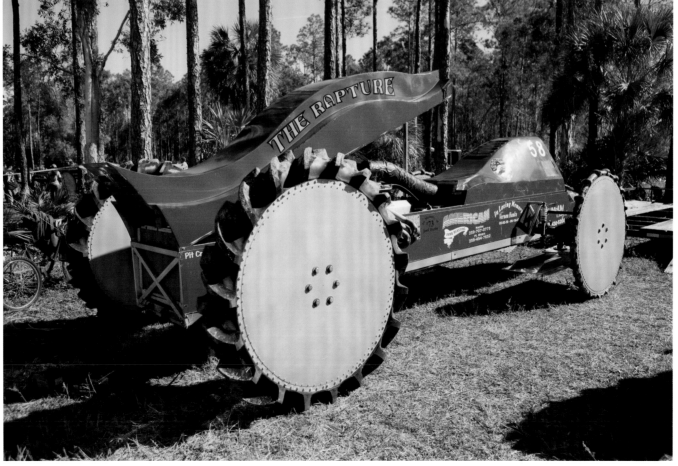

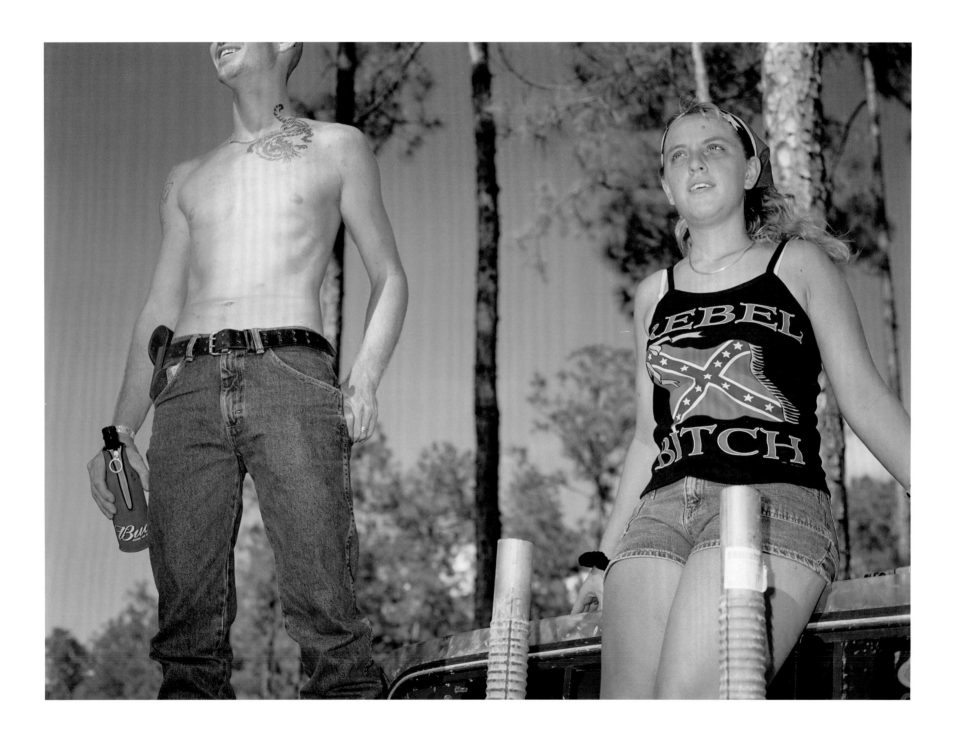

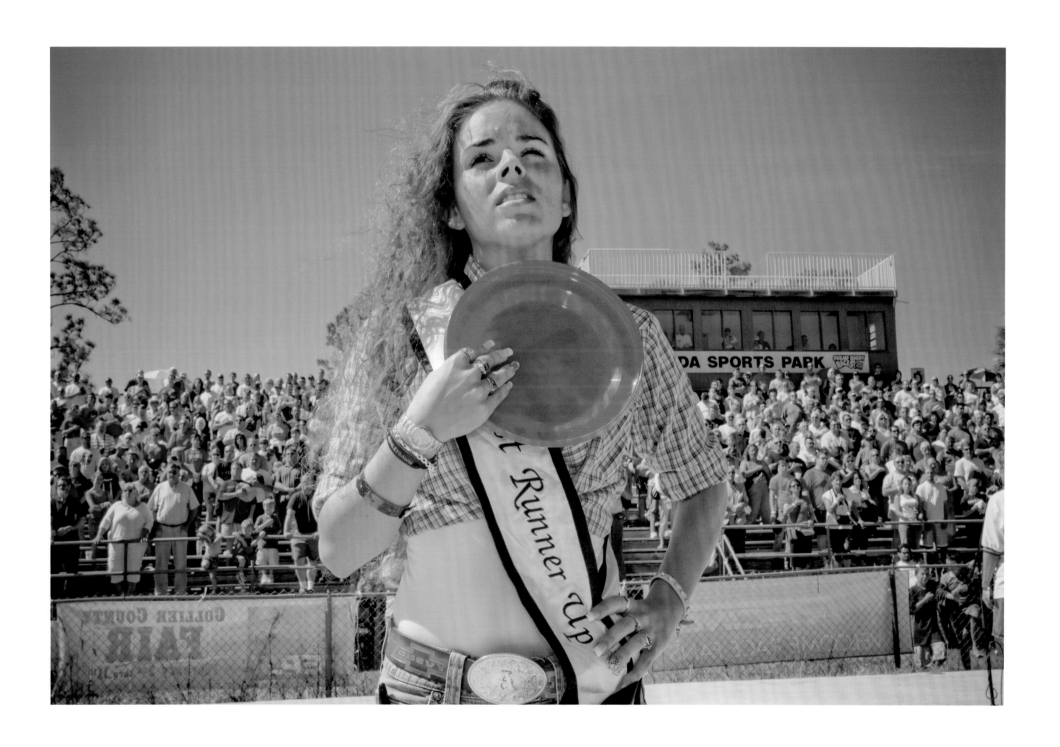

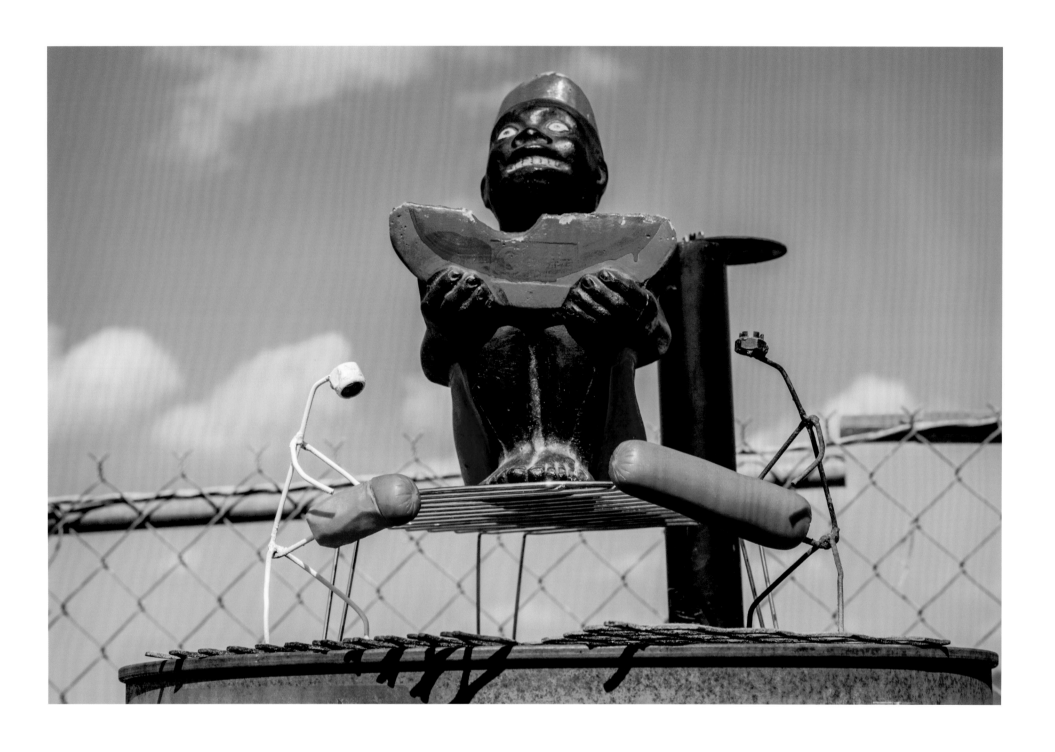

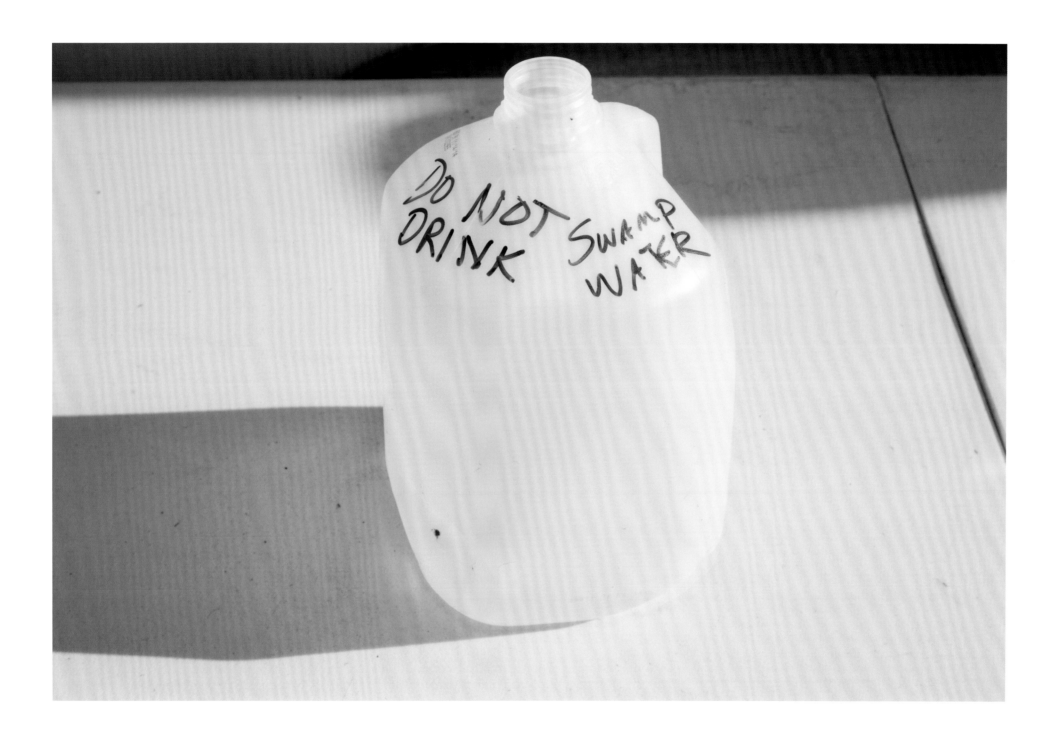

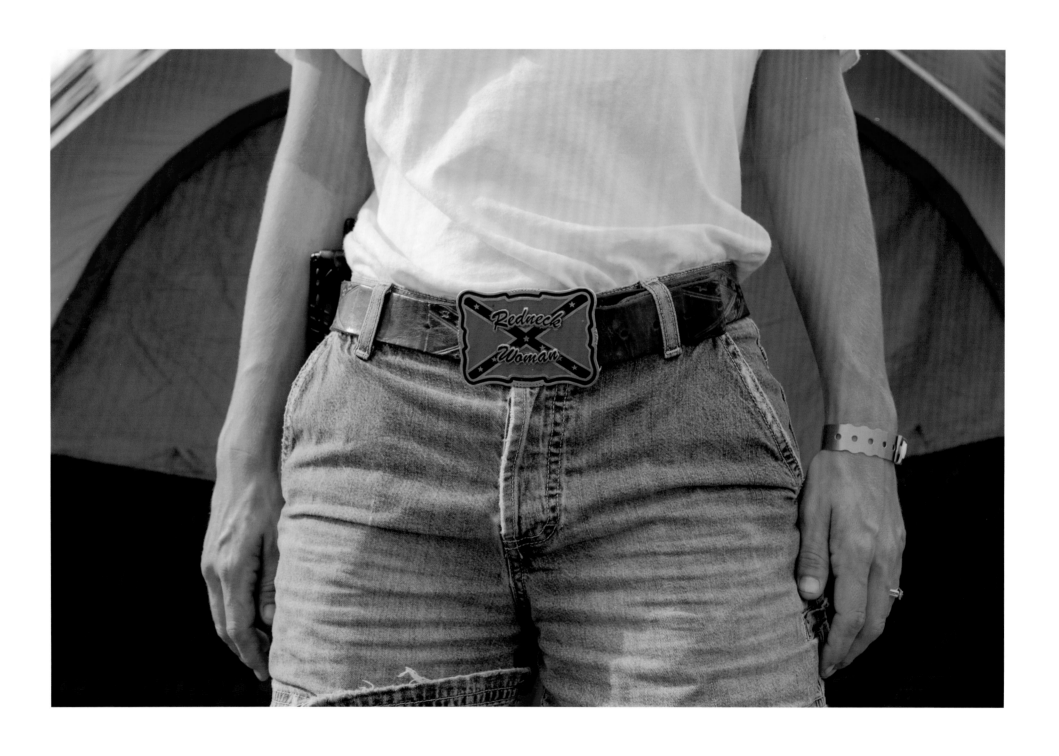

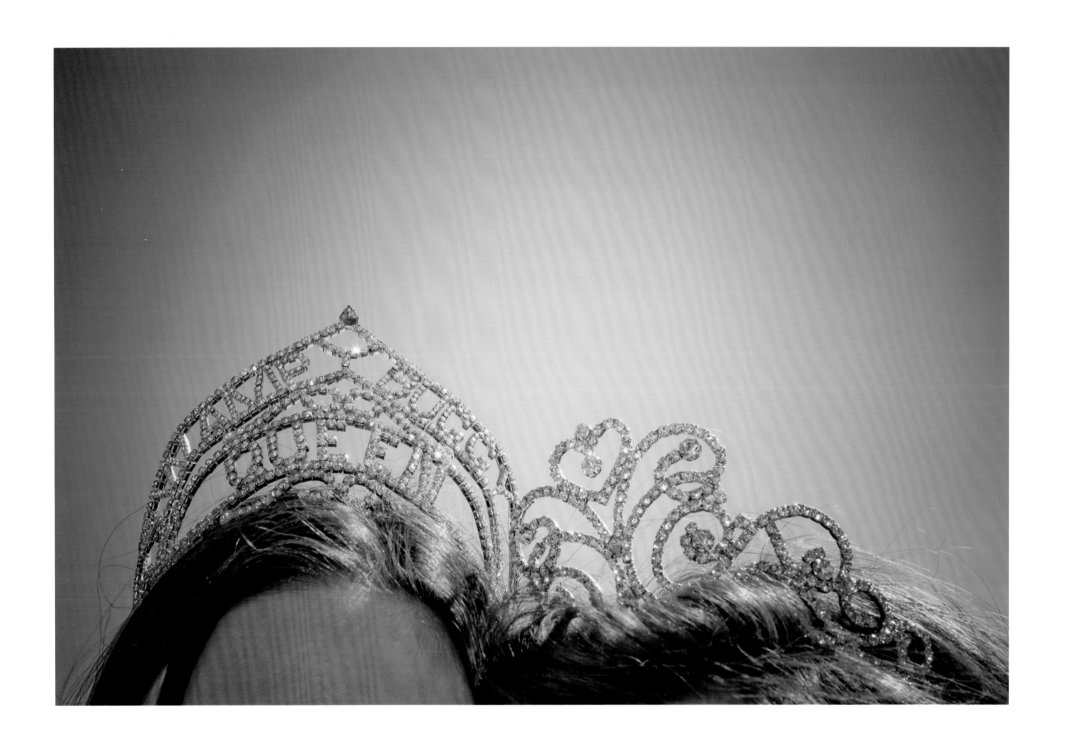

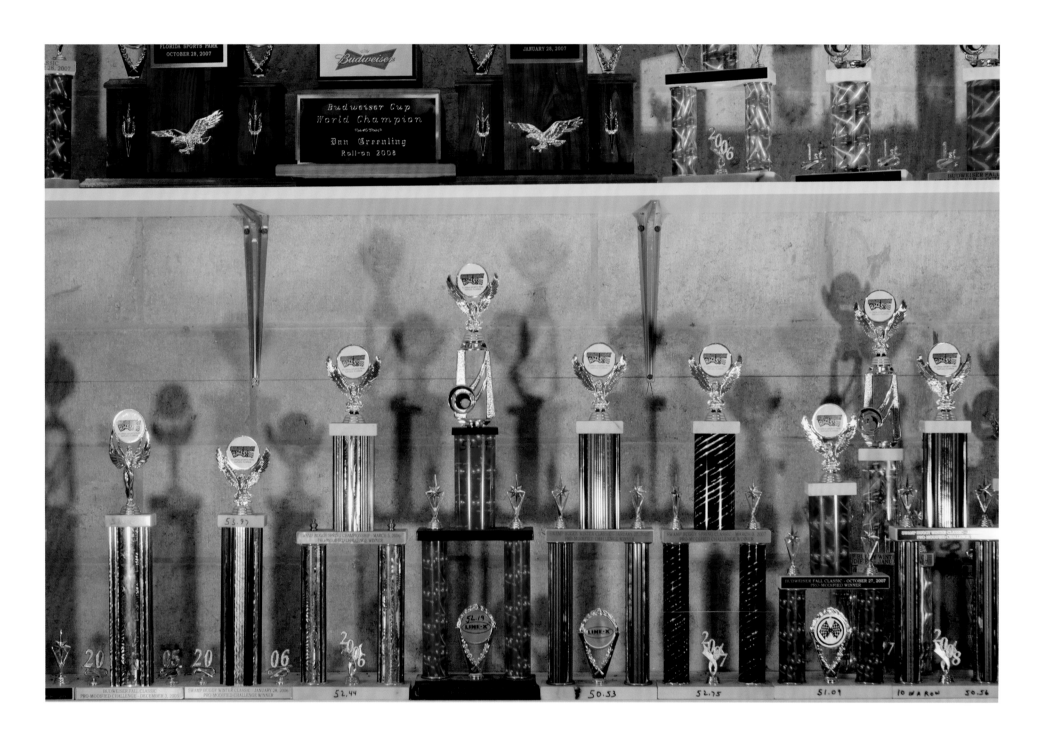

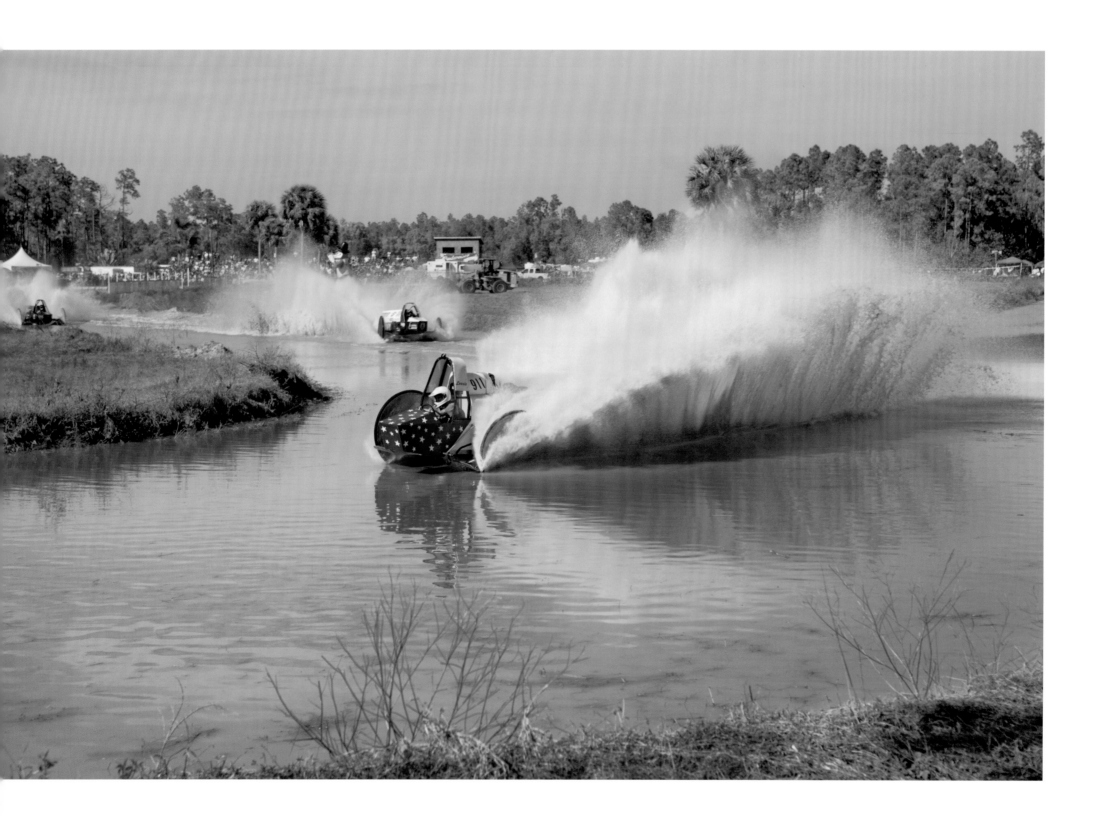

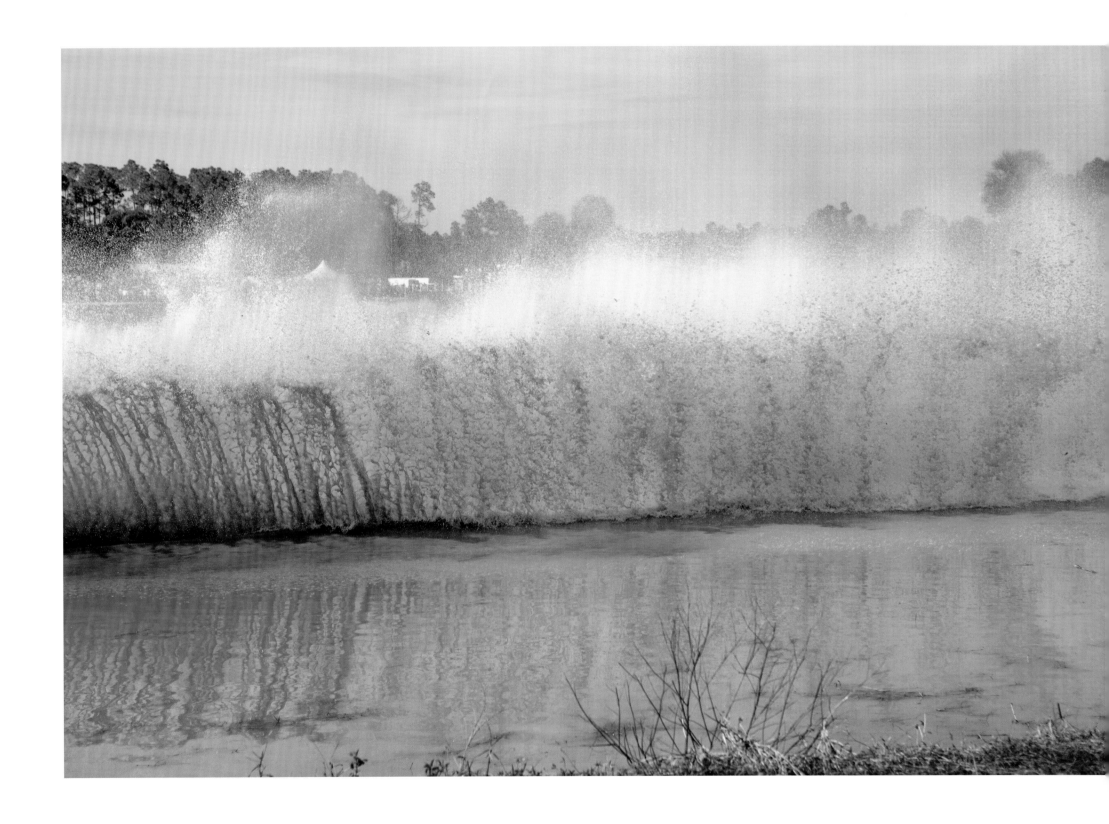

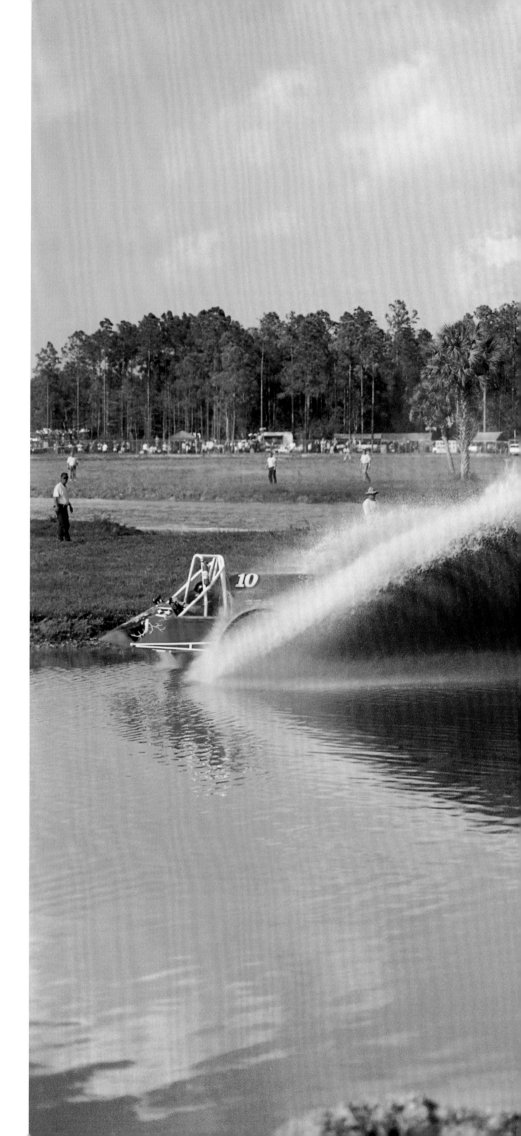

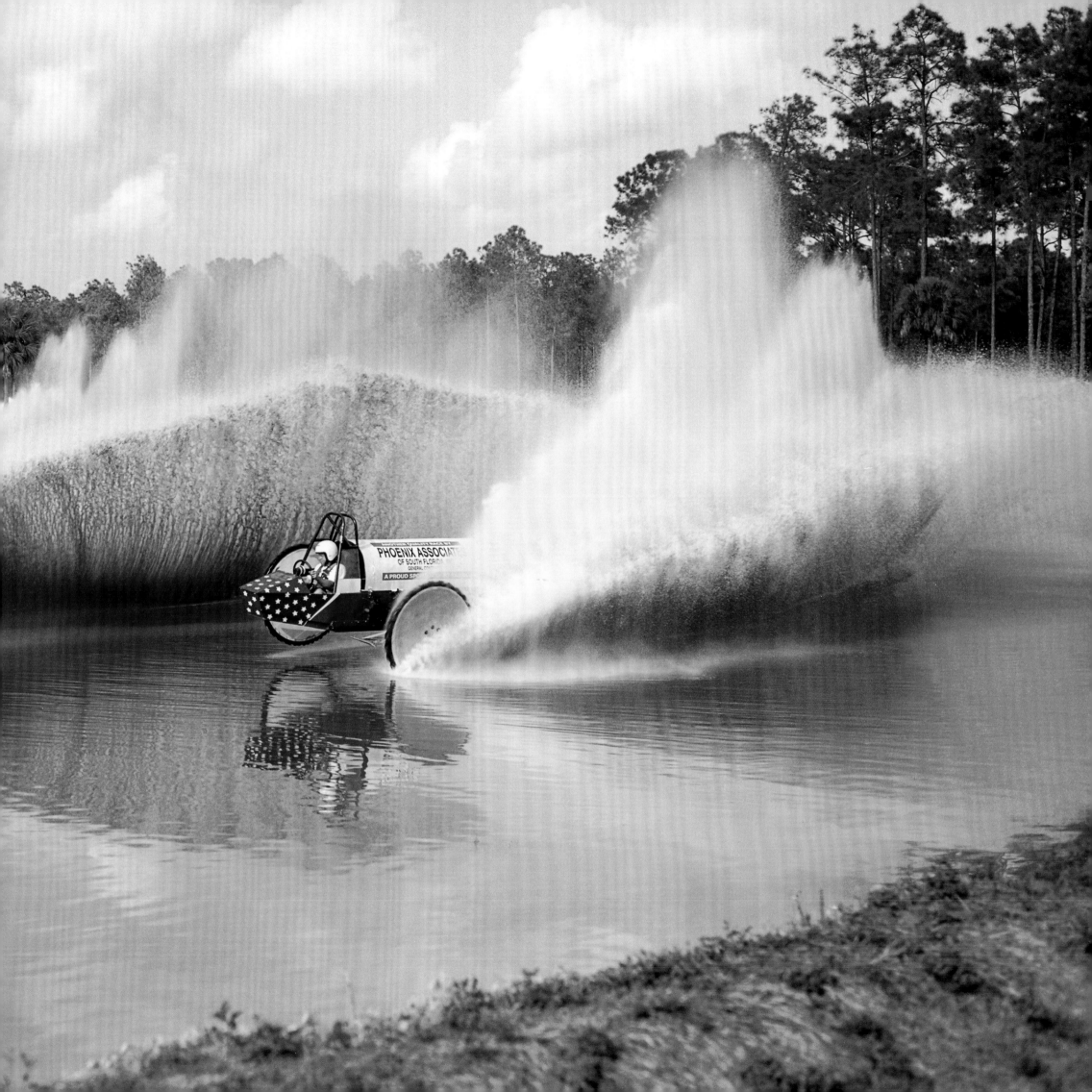

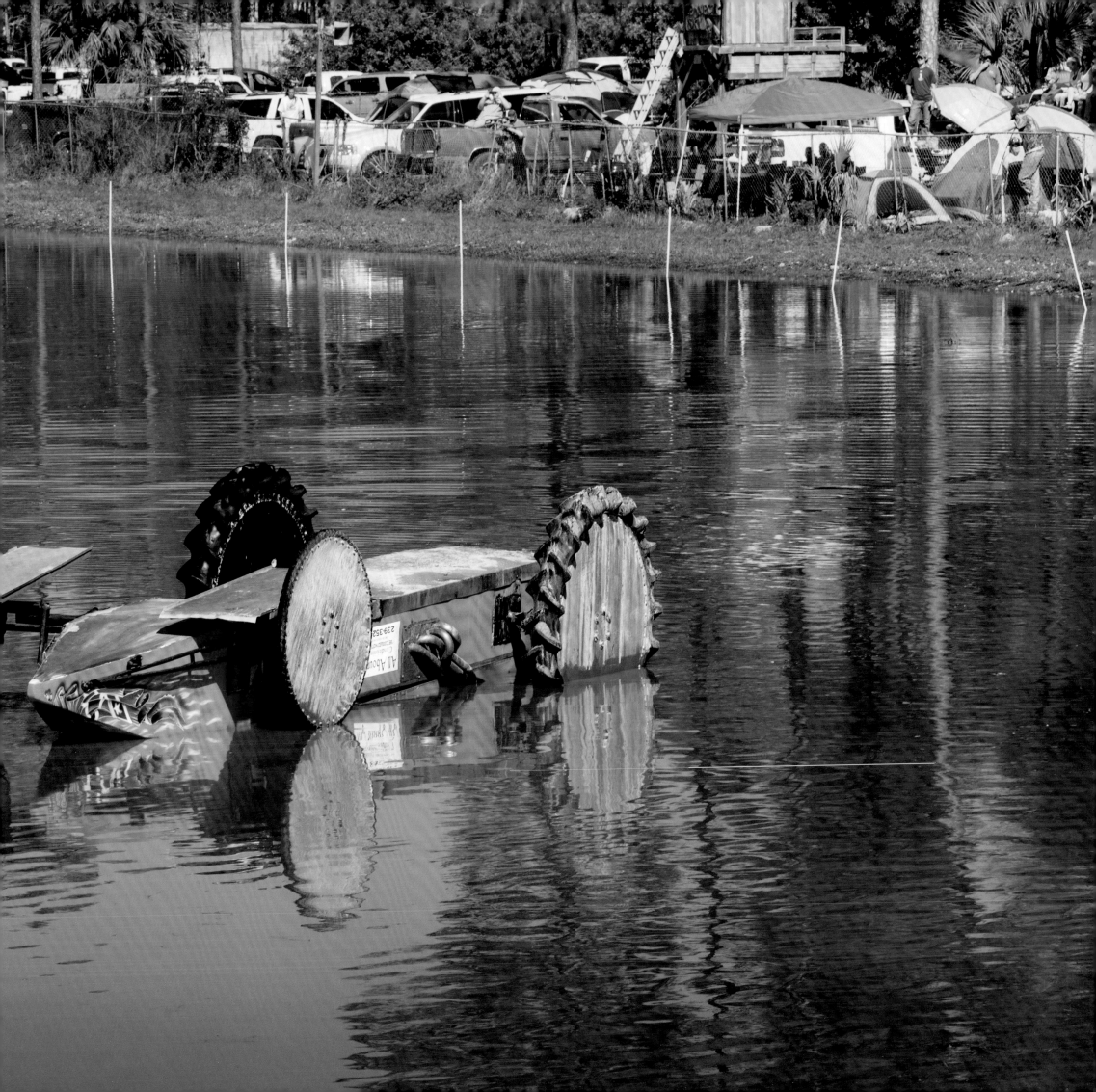

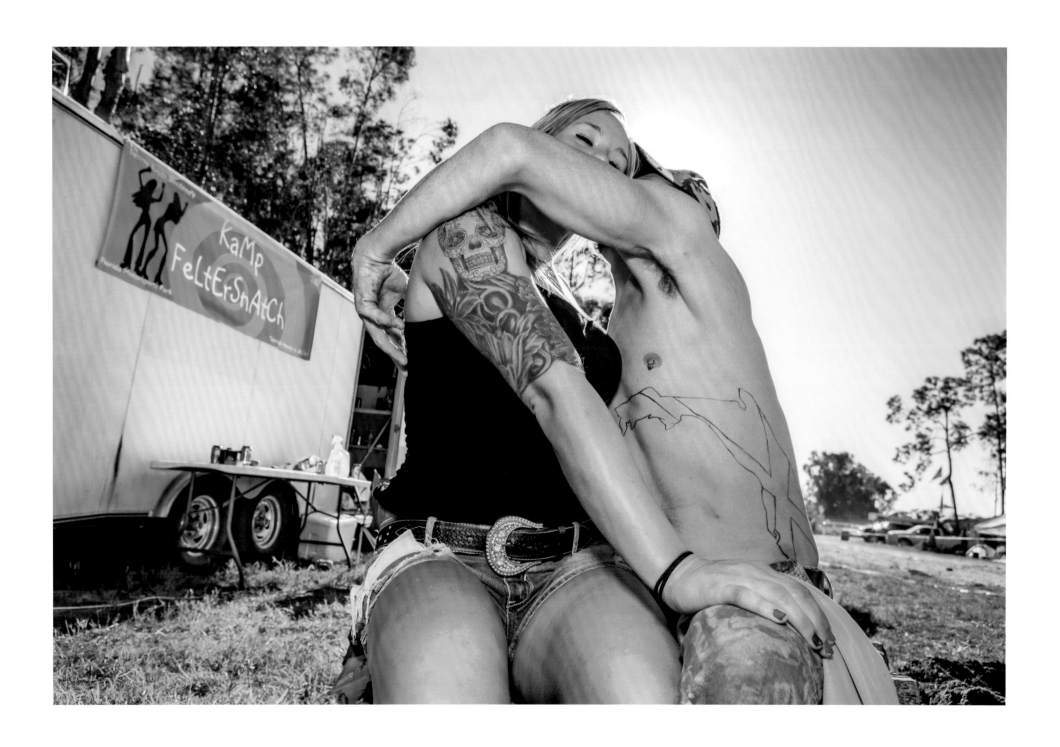

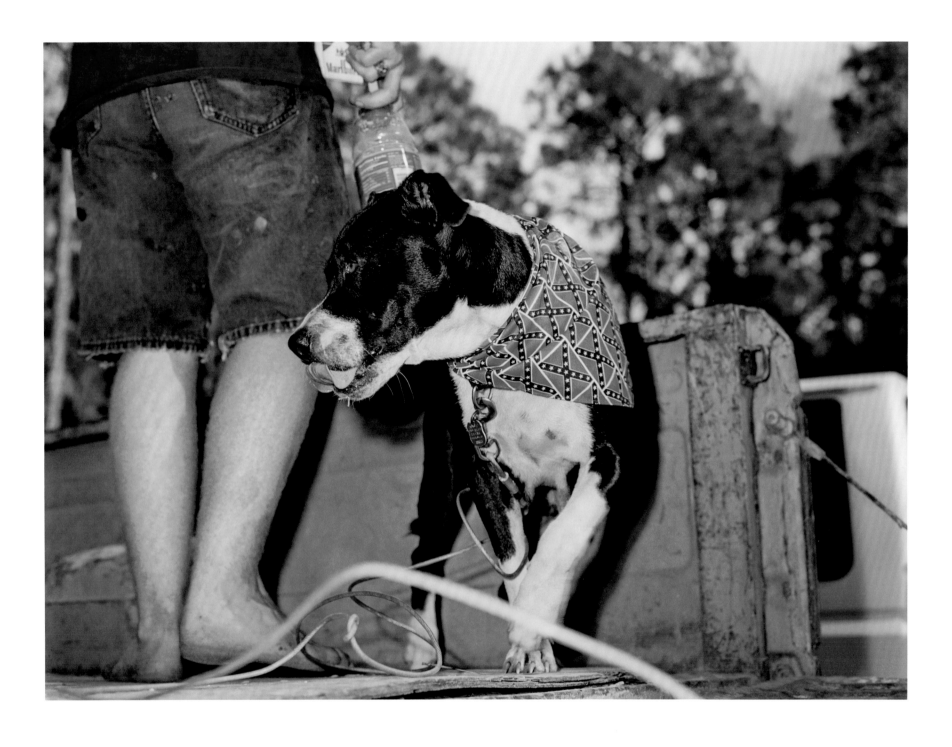

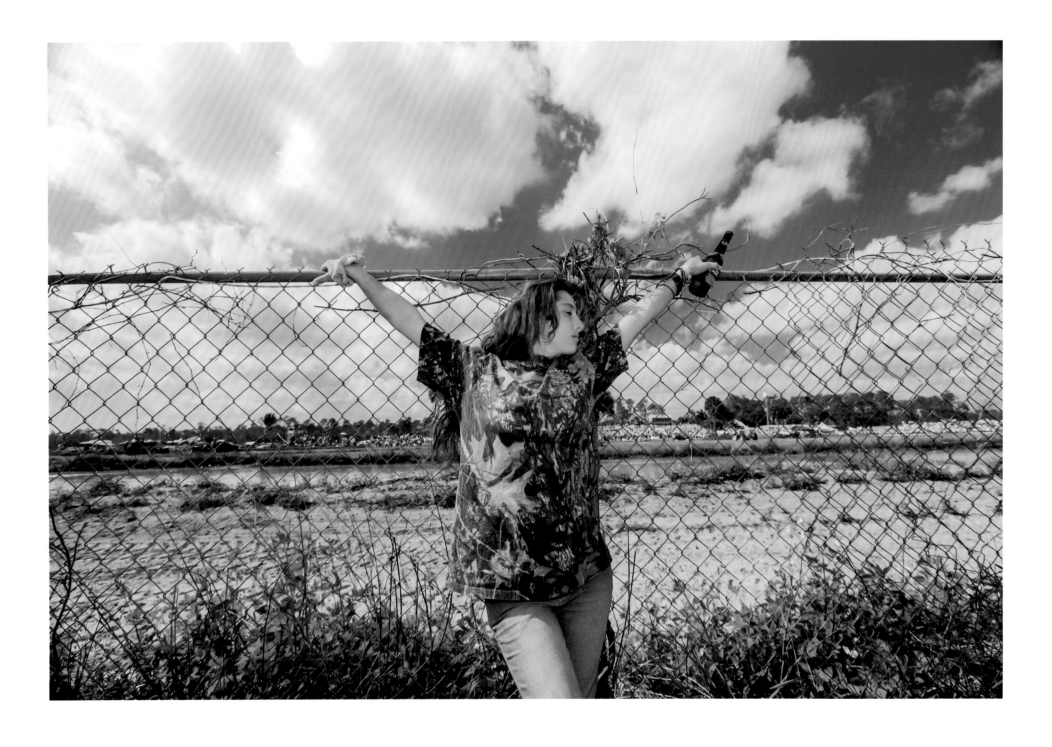

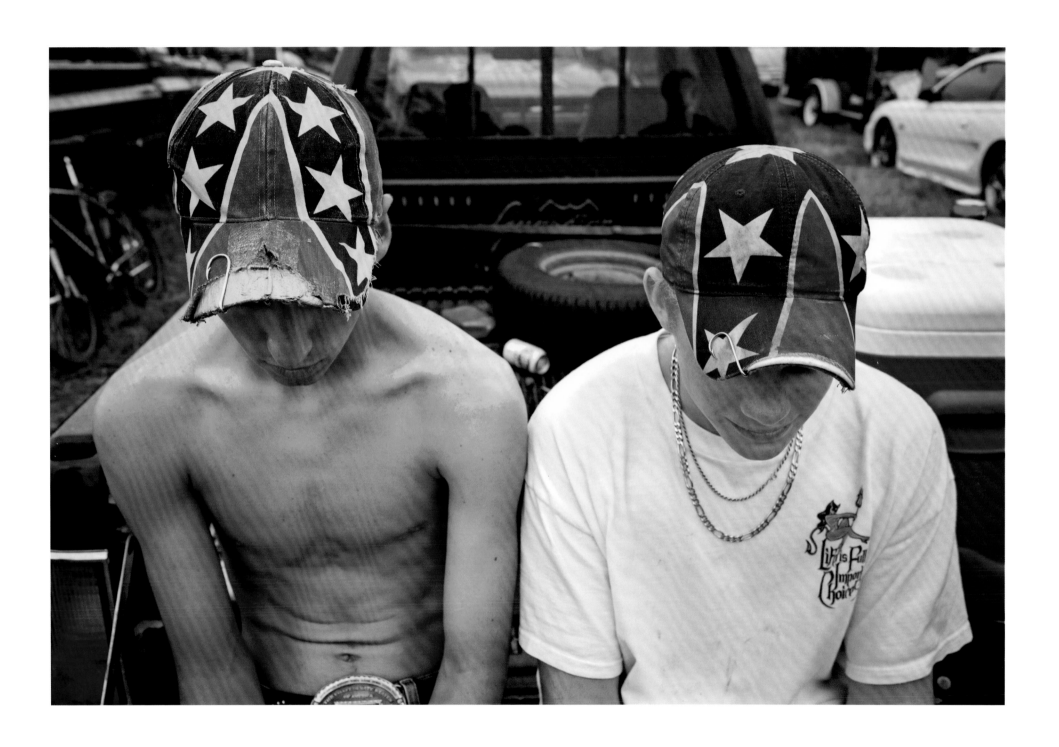

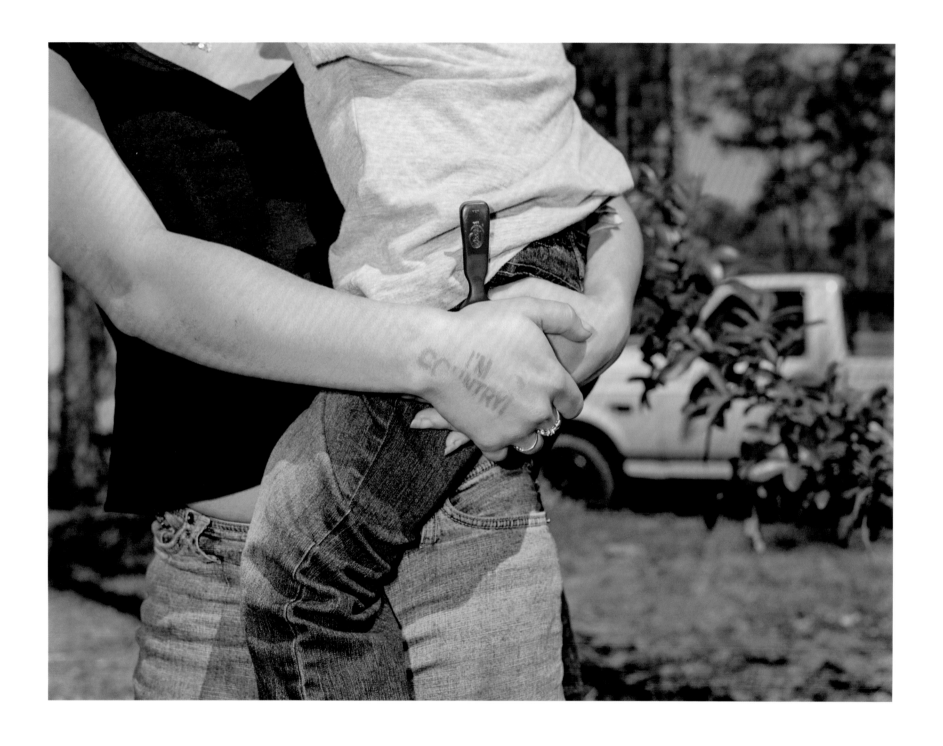

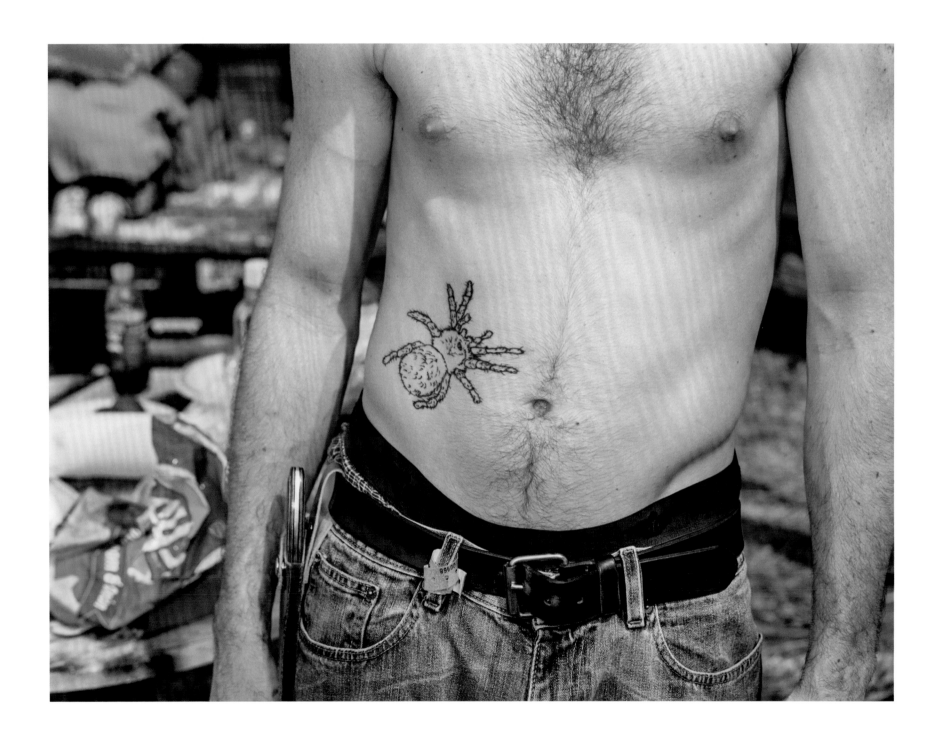

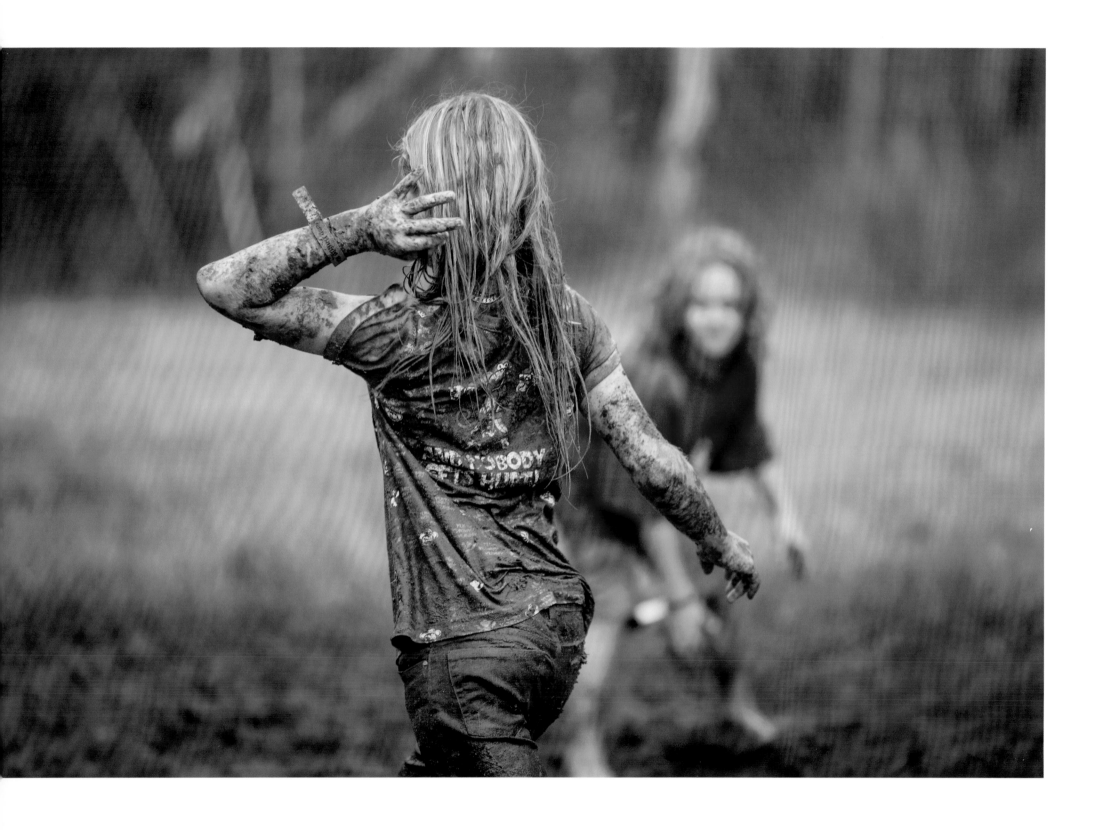

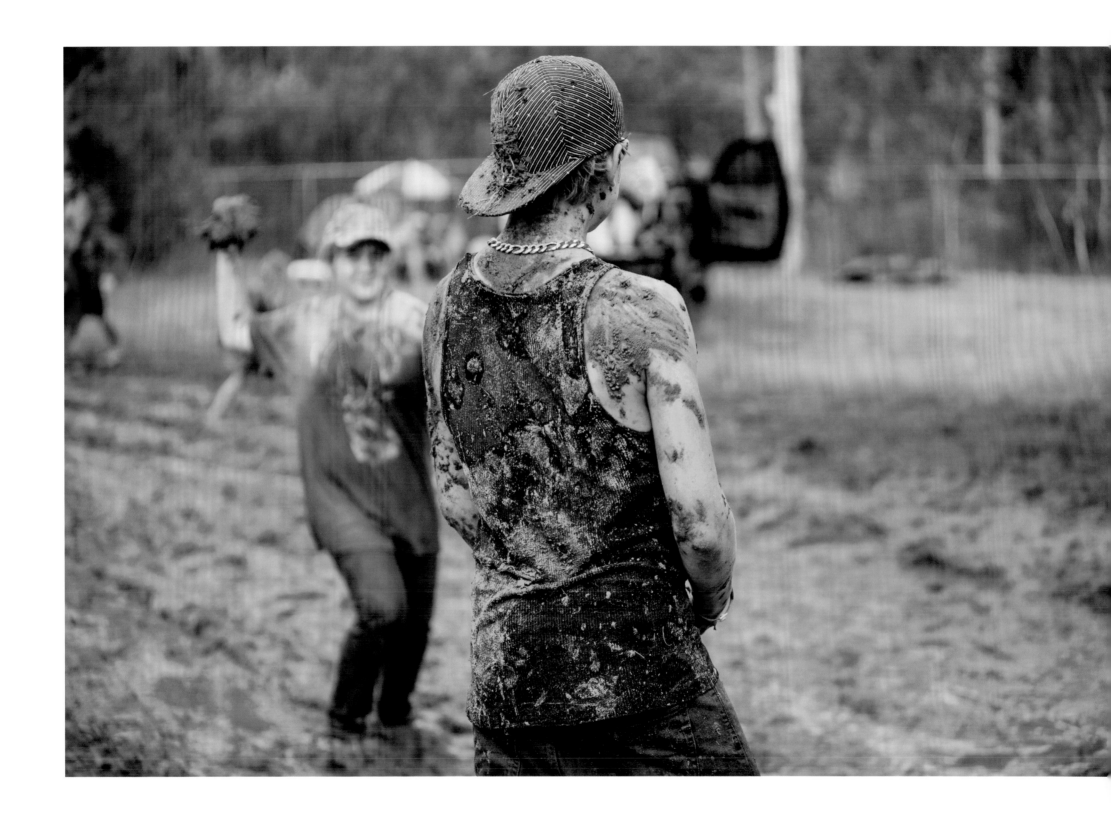

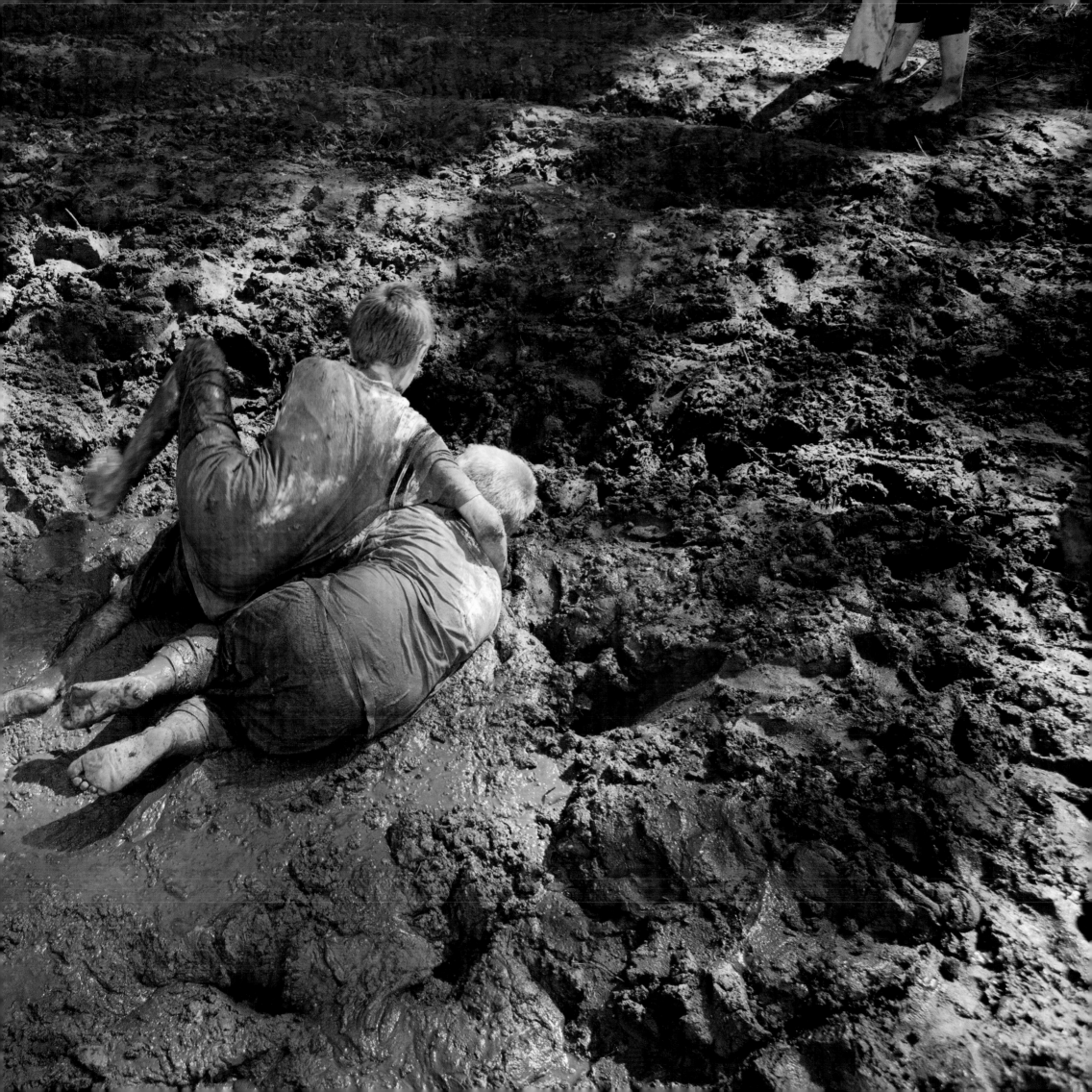

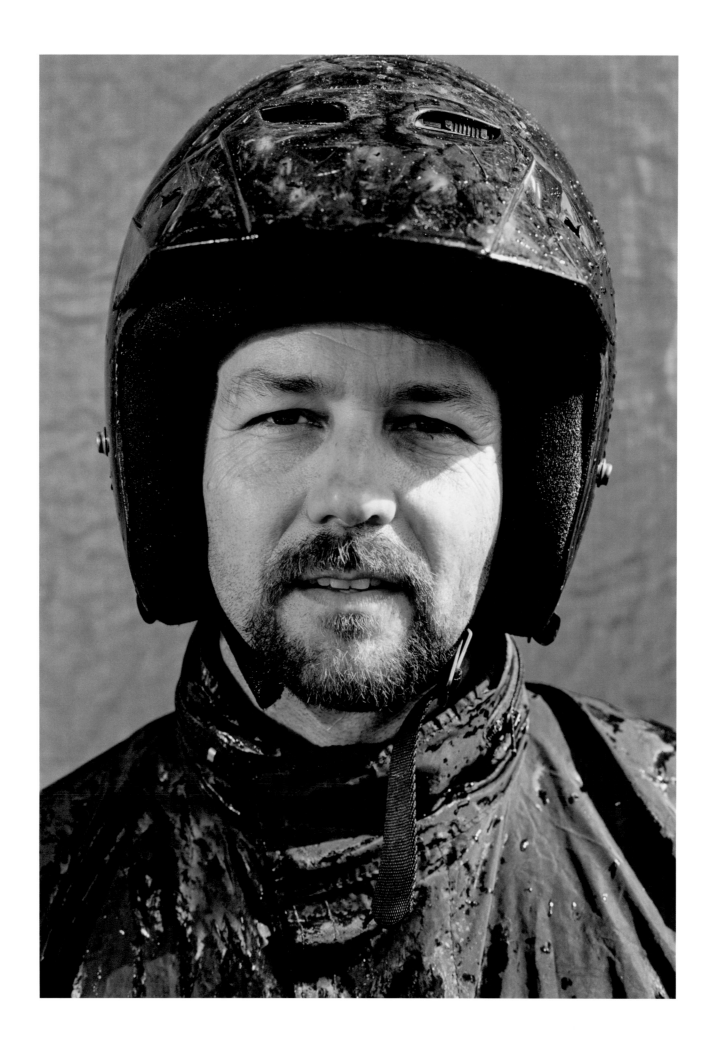

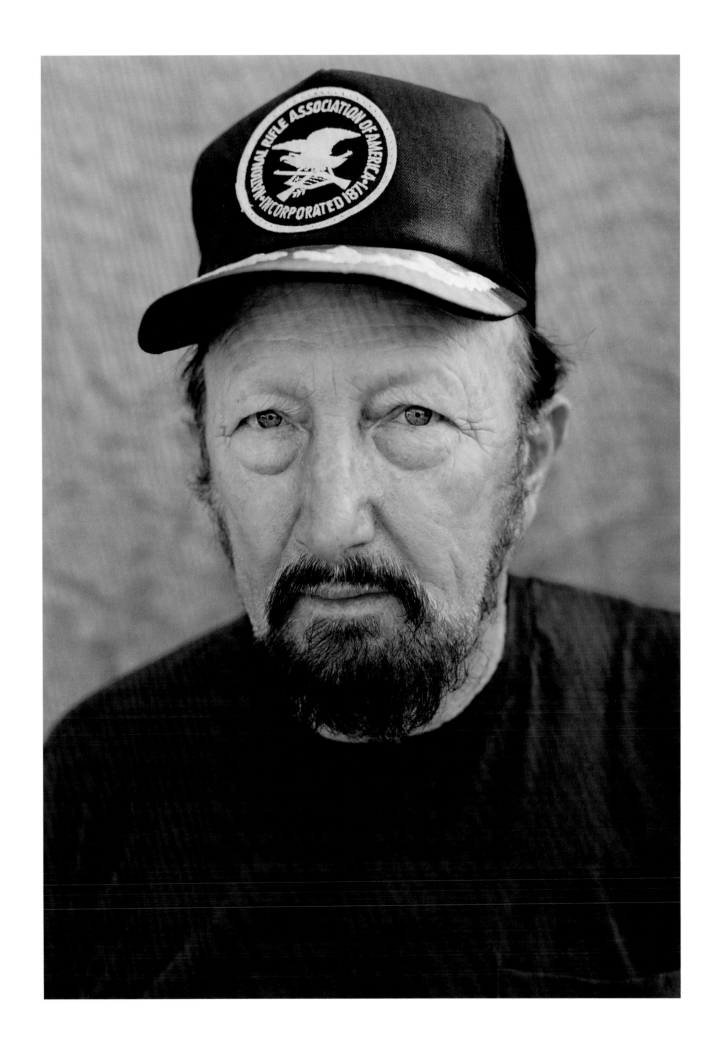

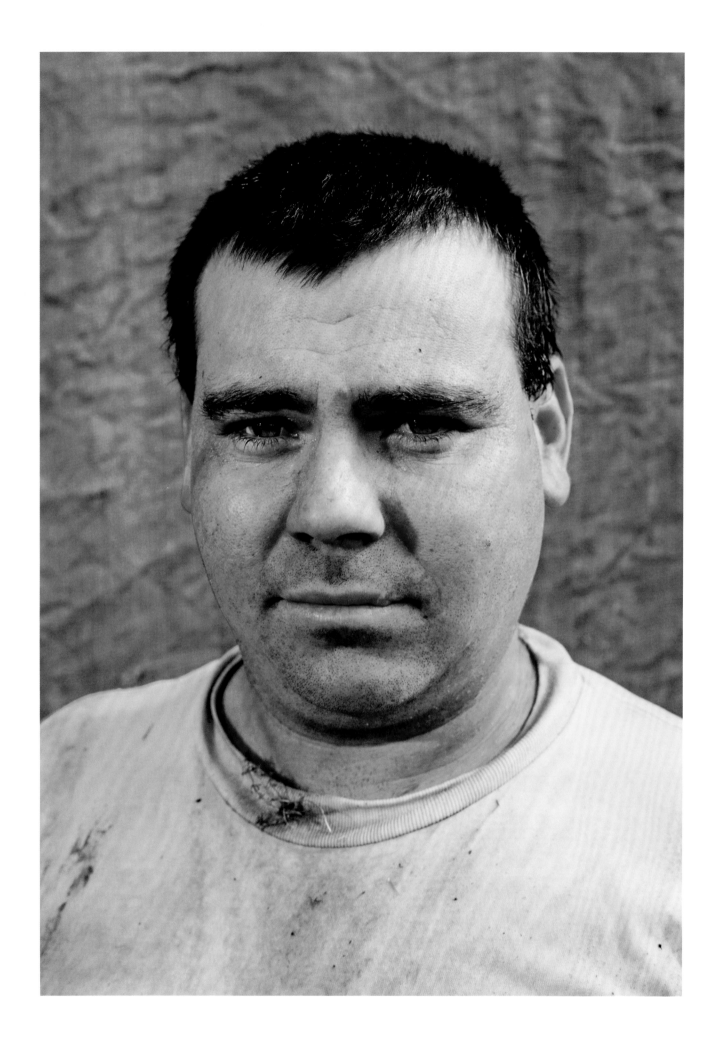

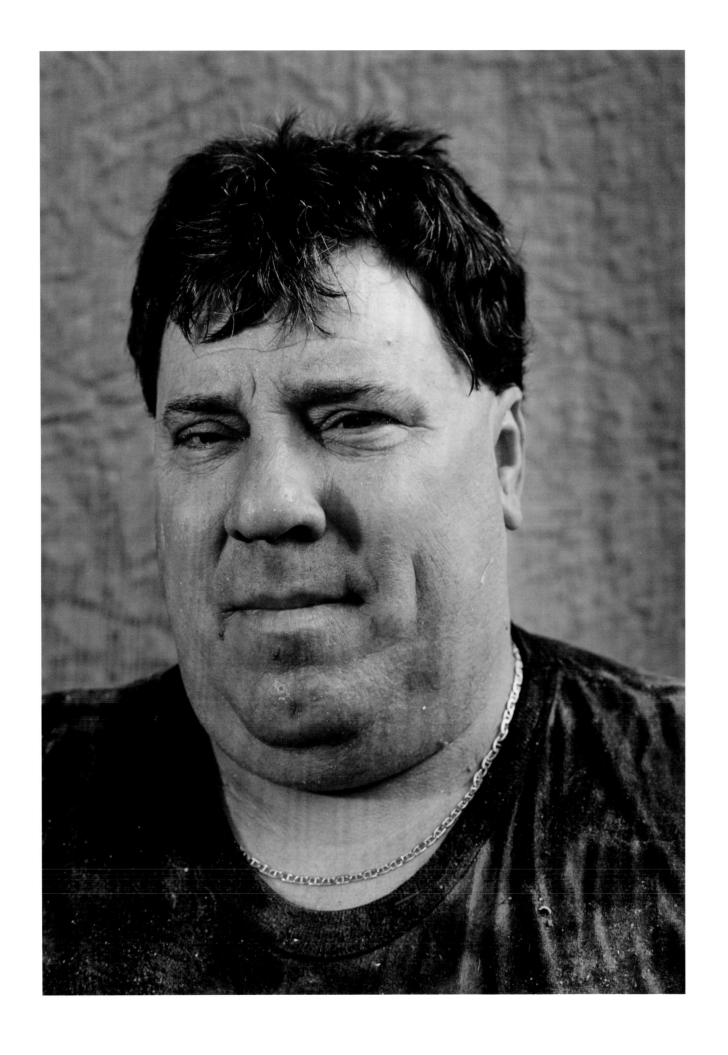

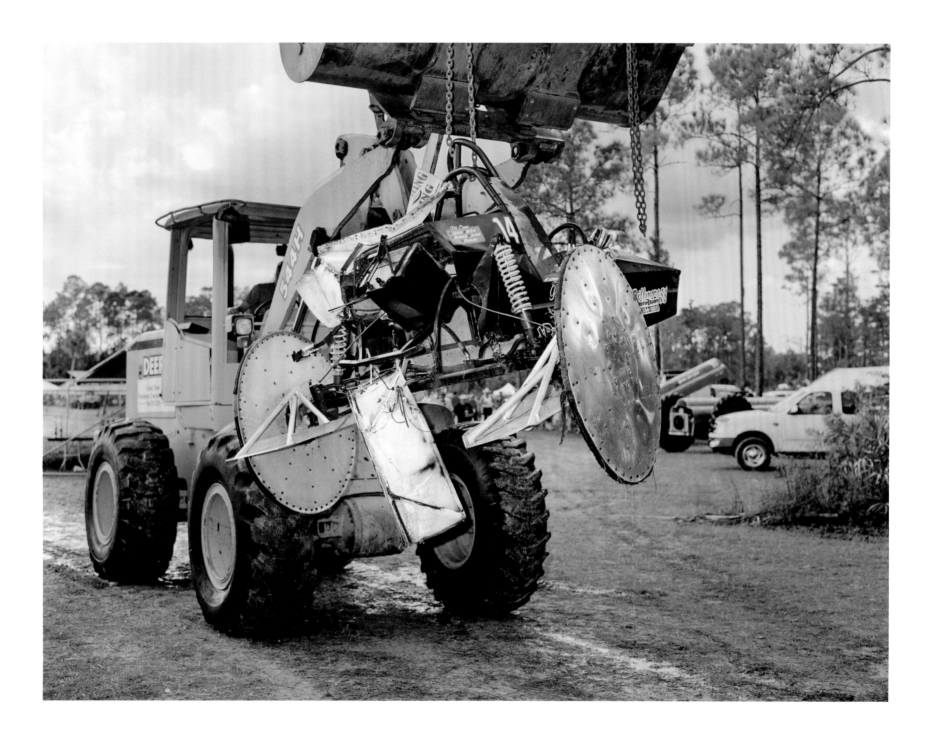

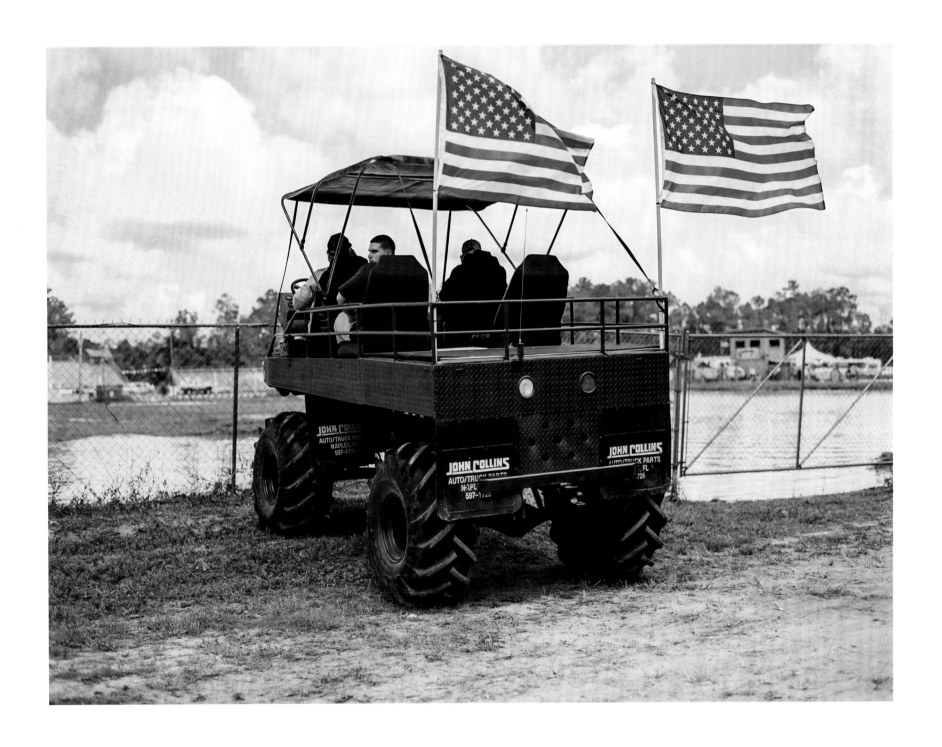

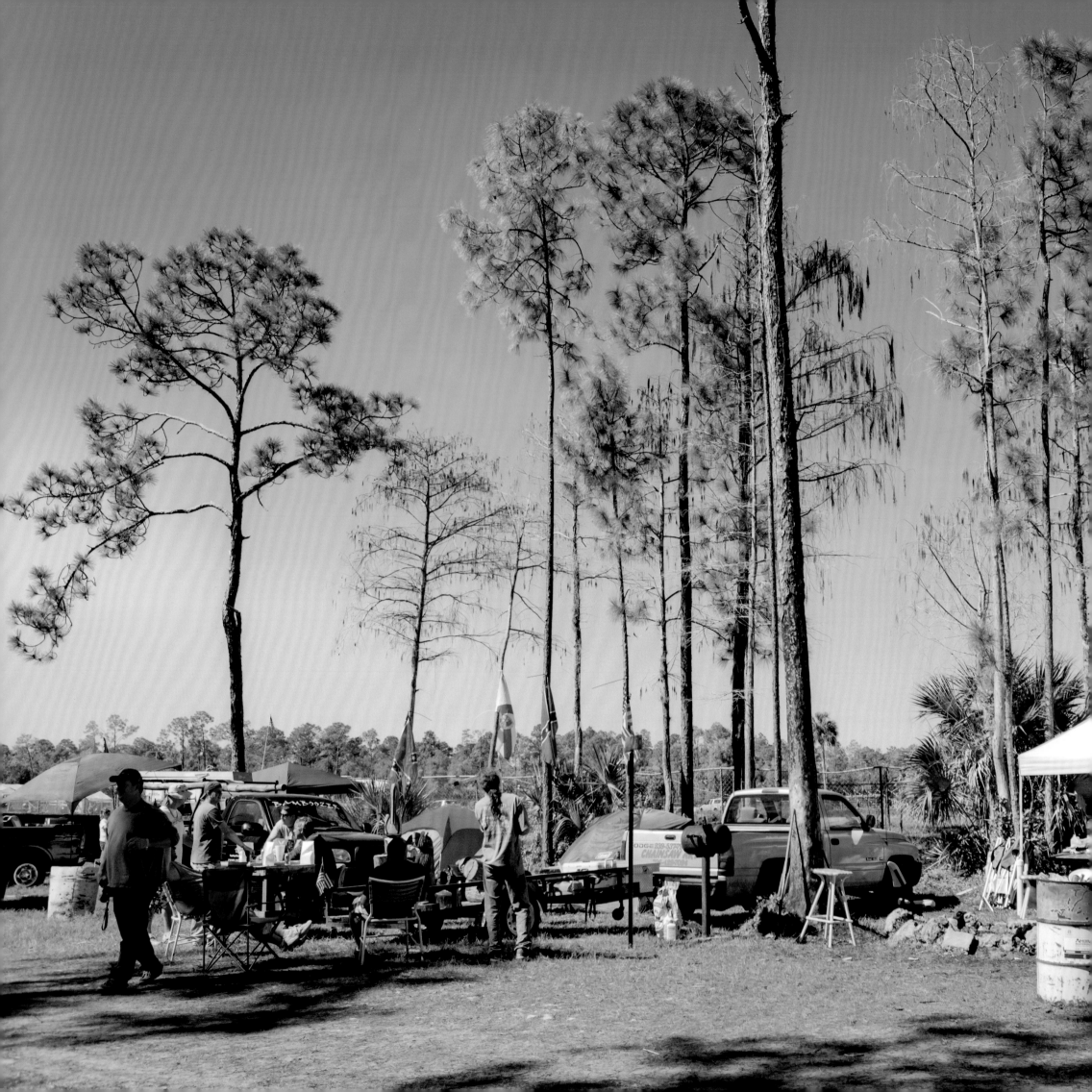

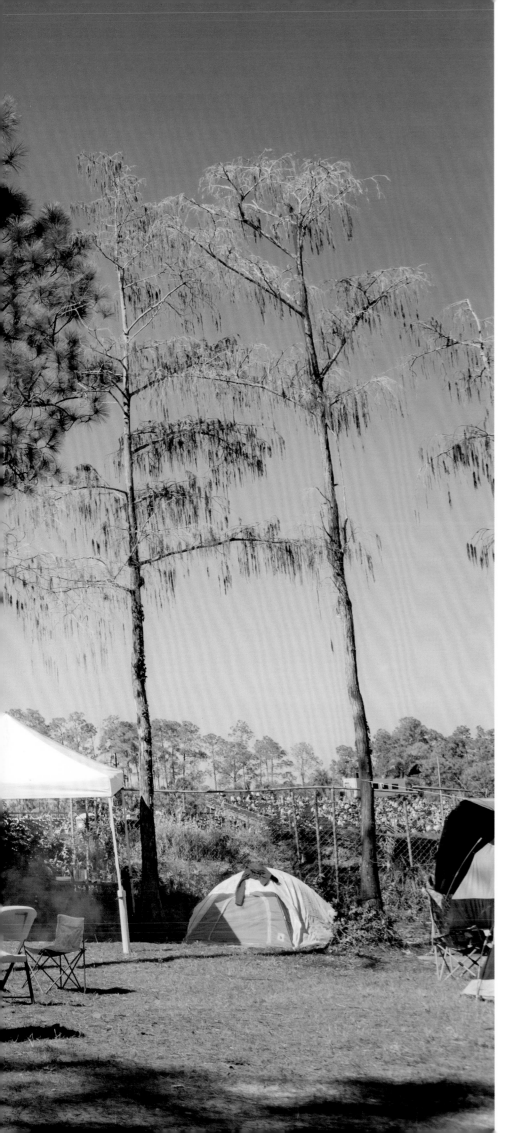

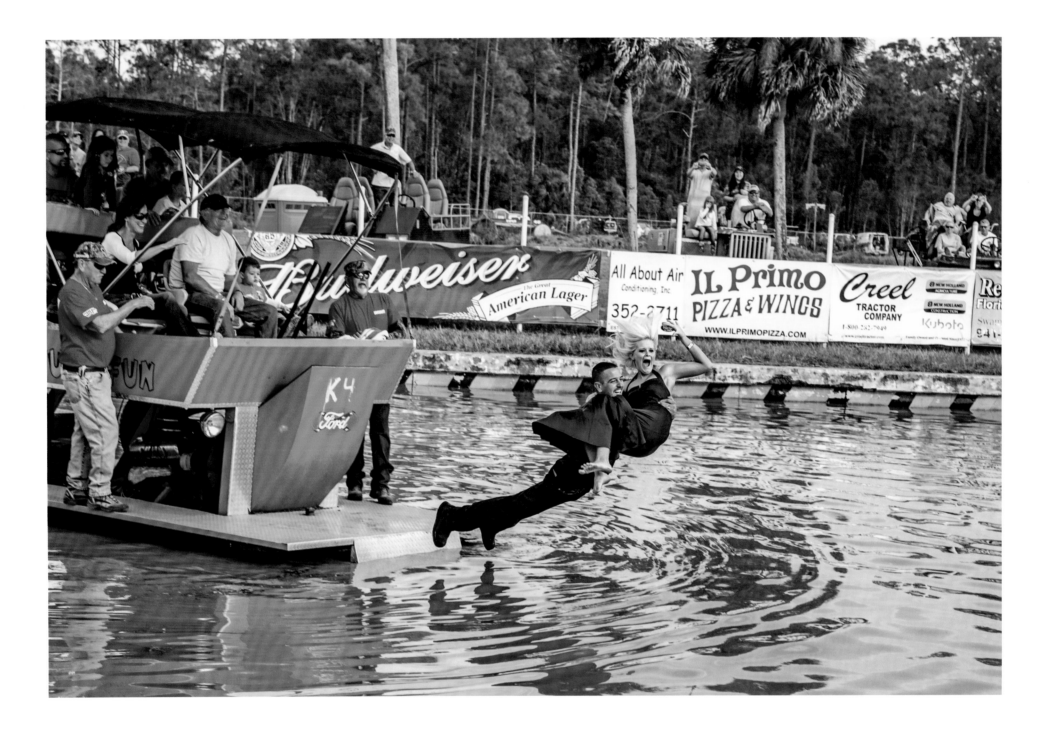

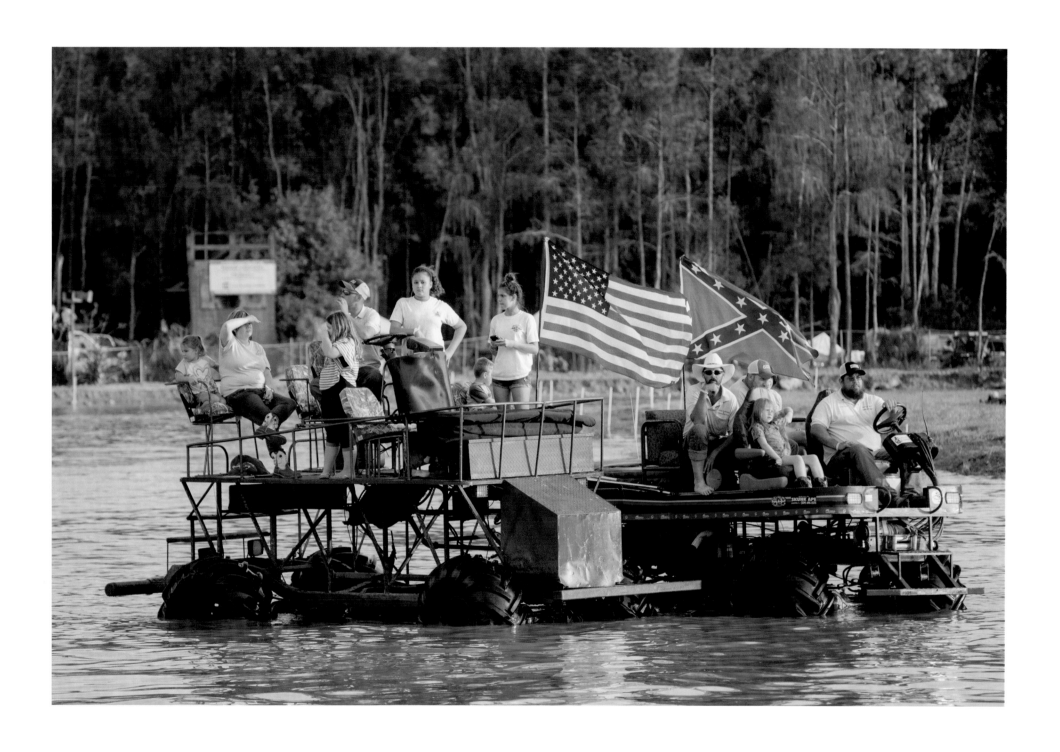

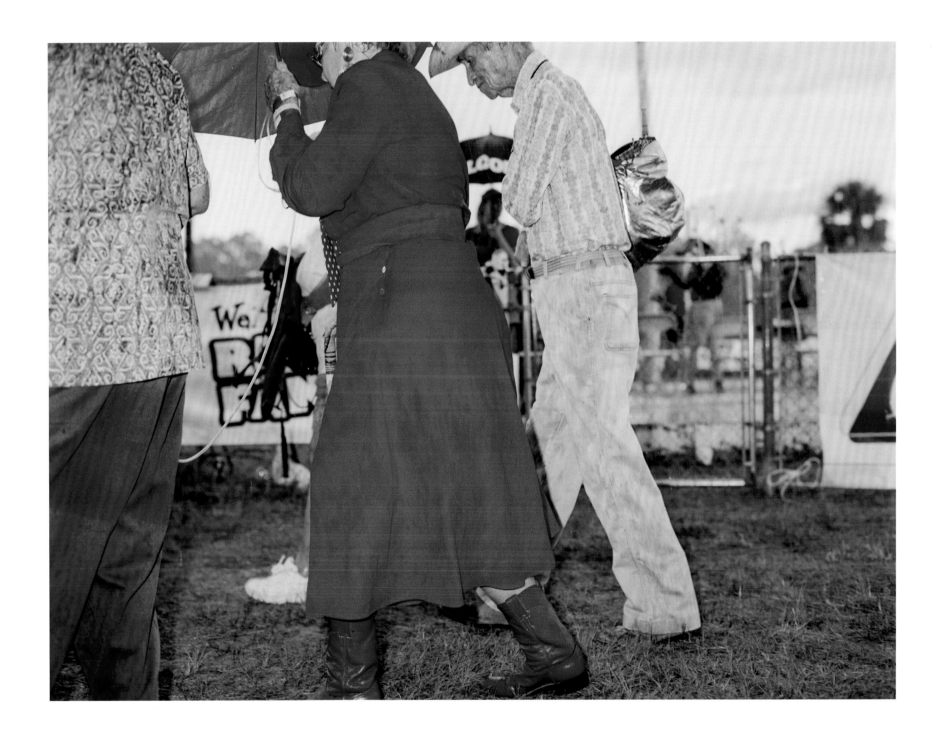

Swamp Buggy Way, 2008

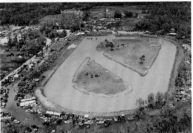

Mile O' Mud, 2008
The Mile O' Mud is an oval track of 7/8 of a mile with a 1/8-mile diagonal lane slashed through the center. The racing lanes are approximately 60 feet wide. On average, the muddy water is four to six feet deep, with three strategically placed holes. The largest hole, located in front of the grandstand, is the treacherous "Sippy Hole," named for the legendary driver "Mississippi" Milton Morris, Swamp Buggy King 1955, who repeatedly got stuck in it.

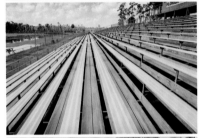

Bleachers, 2008
The grandstand seating capacity at the Florida Sports Park is 8,000.

Off Season, 2008

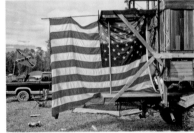

Pride, 2008

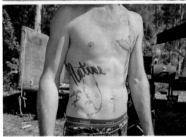

Native, 2011
This native Floridian, or "Florida Cracker," has a tattoo illustrating the state of Florida with a fishhook piercing the location of Collier County along its west coast where the swamp buggy races originated.

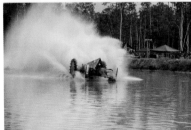

Troy Ortega, Terminator III, 2008
Troy's custom buggy is modeled after an F-117 stealth fighter.

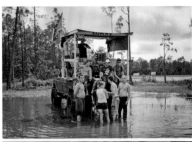

Lumpy, 2008
"She took a half step too far when she went to kick me in the ass. Needlesstosay, they swelled like oranges and she started calling me 'Lumpynuts.' In time, it shortened to just 'Lumpy.'" —Chris Steinmann

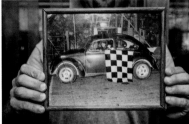

Checkered Flag, 2008
Eddy Chesser, son of Lonnie, holds a photograph of himself when, as a teenager, he won a race event in his VW, which sported a rebel flag draped across the back seat.

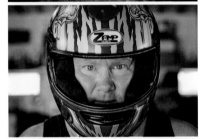

Terry "T-Bone" Walsh, Bounty Hunter, 2008
Originally from Chicago, Terry Walsh owns and operates a hauling company with his wife, Bonnie. They also own an exotic-animal shelter, which houses monkeys, camels, birds, and zebras. He has been called "T-Bone" since childhood and does not remember why.

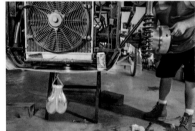

Truck Nutz, 2008

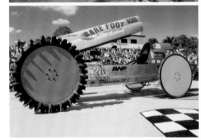

Bare Foot, 2013
Bobby Williams, driver of Bare Foot, is a third-generation native of Naples. He has owned Archie Williams Plaster and Dry Wall for 25 years and is also an accomplished musician.

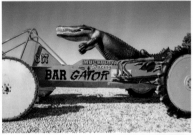

Bar Gator, 2013
John "Allen" Barfield drove the Bar Gator swamp buggy. The fabricated giant alligator, which appears to be attacking the driver, is mounted on the back of the buggy and is one of the most unusual designs at the Florida Sports Park. Barfield hailed from Clewiston and passed away Feb. 15, 2015. Allen, as he was called, was the co-owner of Everglades Machine Shop and the owner and crew leader of Muck Boyz racing crew.

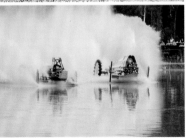

Full Throttle, 2013
Bonnie Walsh and Randy Johns battle in the Pro-Modified race. Bonnie later won the Big Feature racing against Troy Ortega with a time of 50.95 seconds.

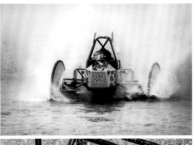

Bonnie Walsh, Fatal Attraction, 2008
Bonnie began her racing career in 1976 when the Mile O' Mud was located off of Radio Road and at that time they held an unofficial "powder puff" race for female drivers. In 2005, Bonnie became the first woman swamp buggy driver to claim the Budweiser Cup Championship.

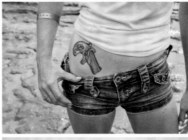

Lady Derringer, 2008

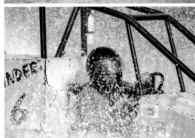

John Parks, Sidewinder, 2008

Red Horns, 2006

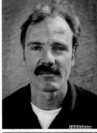

Tony Hamm, 4 Play, 2004
An automotive technician by trade, Tony has been involved in buggy racing his whole life and built his first buggy, The Old Duck, in 1995. His uncle competed in the first official race in 1949 in his buggy the Lonesome Polecat. Tony's most memorable moment was competing against his all-time hero, Lonnie Chesser.

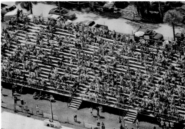

Race Fans, 2008
The average number of spectators per race event is 6,000.

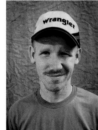

Wrangler, Race Fan, 2004

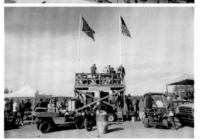

Redneck Stadium, 2011
The name "Redneck Stadium" is the creation of Daniel Patrick Hoolihan, IV, who defines rednecks as "people who would probably be having more fun than others." He and his wife Dawn have been attending the races for 25 years.

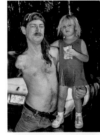

John "Lefty" Cusick and Rose, 2002
Originally a Northerner, Lefty lives in Naples and is a dedicated race fan. He lost his right arm in a manufacturing accident. He is pictured here with his daughter Rose.

Swamp Buggy 4-Sale, 2011

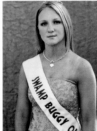

Courtney Jolly, Swamp Buggy Queen, 2004
The Swamp Buggy Queen Pageant is held every April, and one contestant is chosen to preside over all Swamp Buggy Race related activities. After Courtney's 2004 tenure as Queen, this seventh-generation Floridian began racing her own swamp buggy alongside her mother Bonnie Walsh. She later went on tour racing Monster Trucks and is currently a real estate agent.

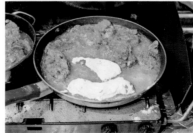

Fried Venison, 2005

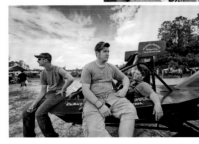

Andy Sims and Crew, Pressures On, 2008

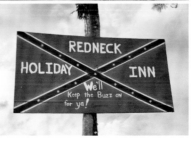

Plywood Southern Cross, 2006

Southern Black Racer, 2008

Spiral Cut Ham, 2006

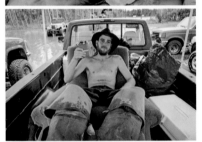

Lazy Boy, 2008
"We commonly refer to that little area of ours as 'vendor row' because we are always cooking something, but we don't charge for food. We all are like a big happy family. If you need it and I have it, it's yours. Sometimes we don't see each other but three times a year. We shake hands, give a man-hug, drink a beer, and eat some food and exchange stories. No better people to be around." —Don Hatfield, Jr.

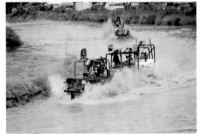

Jeep Scramble, 2008

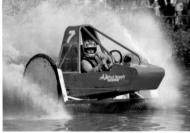

Hard Turn, William Thornton, Cold Duck, 2008

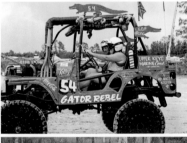

Kelley McMann, Gator Rebel, 2002

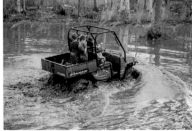

Four-Wheelin', 2008

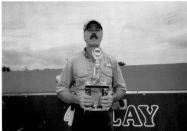

Superstock Trophy Winner, Tony Hamm, 4 Play, 2008
Tony is considering selling his buggy and getting out of racing because of the expense. He spends an average of $3,500 on the engine while others are investing upwards of $50,000.

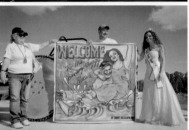

Welcome, 2008
After winning the feature event in 2007, Dan Greenling held the honor of dunking the queen, Ashleydawn Wells. He was then represented with a painting of the traditional queen mud bath. Dan then won the next race event of the year and dunked Ashleydawn a second time. The "dunking" tradition began in 1957 when winner H.W. McCurry, in cheerful celebration, grabbed the Queen—gown, fancy hair-do, and all—and jumped into the deepest and muckiest part of the racetrack.

Turkey Drums, 2006

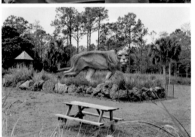

Florida Panther, 2002
In 1982, the Florida panther was chosen as the state animal. An endangered subspecies of the cougar, the panther lives in the forests and swamps of southern Florida. "Panther Crossing" signs can be found along roadways throughout the swampy areas of Collier County. This fabricated panther is located off the Tamiami Trail at the Skunk-Ape Research Headquarters in Ochopee.

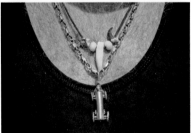

24-Karat Swamp Buggy, 2006
For $1,600, Terry "T-Bone" Walsh had a solid gold buggy pendant custom-designed by a local jeweler.

Amber, High School Graduation, 2006

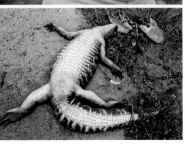

Alligator Alley, 2002
First opened in 1969, Everglades Parkway extends from Naples on the west coast of Florida to Broward County on the east. The American Automobile Association invented the nickname Alligator Alley because of the large number of alligators in the waterways on either side of the road, which the AAA believed would render it useless to cars.

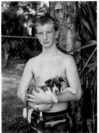

Robert Holding a Puppy, 2002

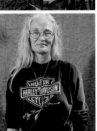

Ann Scroggins, 2004
Ann is Tony Hamm's mother. She is proud that her son has built most of the transmissions for the buggies competing in the races today. While she enjoys watching the "big buggies," she prefers the old-style woods buggies that were built for hunting rather than speed. Ann added, "Whoever could get around that thick marl track in a woods buggy you knew could also put meat on his family's table."

Steve Turner, Turner Loose, 2004
For Steve, who is a heavy equipment mechanic and began racing in 1986, swamp buggy racing is "a family thing." His grandfather Ralph Turner was one of the original woods buggy drivers in the early days. He recalled, "We ate baloney for weeks so that we could buy a carburetor for the buggy and didn't think much about it, it was just the way it was." Steve enjoys building buggies as much as he does racing them, going from paper design to fabrication and final product.

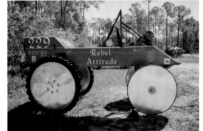

Kat Conrad's Rebel Attitude, 2011

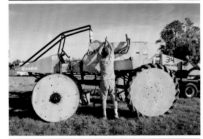

John Park's Sidewinder, 2011

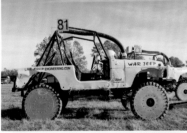

Sean Gould's War Jeep, 2011

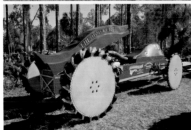

Eddy Chesser's The Rapture, 2011

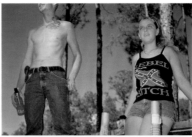

Daniel and Tracey Gordy, Watching the Races, 2002

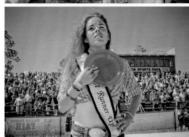

National Anthem, 2006
Ashleydawn Wells was Swamp Buggy Queen runner-up in 2006 and Queen in 2007 and 2008. Half Native-American, she enjoys boxing, football, horseback riding, rodeo, fishing, hunting, motor sports, and tinkering with her classic Chevy Nova.

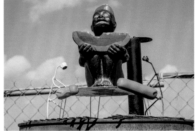

Dick Dog, 2013

Swamp Water, 2013

Redneck Woman, 2008

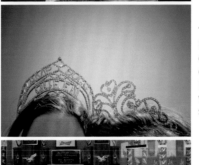

Tiaras, 2006
Naples high school students compete for the Queen's crown in the annual Swamp Buggy Queen Pageant. The chosen Queen presents awards to winners at the Swamp Buggy Races and speaks at public events during race weekends. Her Court consists of the Queen and the first, second, and third runners-up.

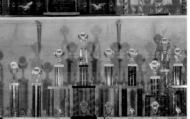

Trophies, 2008
Dan Greenling, driver of Roll-On, had the fastest time trials for 12 races in a row in the Pro-Modified division. Because his engine broke, he lost the 13th but went on to win 10 more. Because time trials are held on Saturdays, his total of 22 wins earned him the name, "Mr. Saturday."

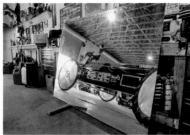

The Walsh's Garage, 2008

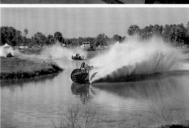

Lorrie Johns in the Lead, 2011
Lorrie Johns, driver of Lady Liberty, became the second woman ever to win the Budweiser Championship Cup, following Bonnie Walsh, who won in 2005. She frequently races against her husband Randy Johns of Top Gun and her son Tyler Johns of Patriot.

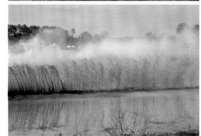

Rooster Tail, 2011

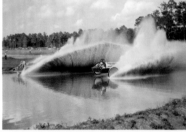

Final Lap, 2003
In the day's finale, Leonard Chesser's blazing-orange, pro-modified, two-wheel-drive Dat's Da One outmuscled Tyler Johns' V-8 Super Stock entry Patriot and the modified four-wheel drive buggy Dat's It, driven by Leonard's 21-year-old daughter Amy.

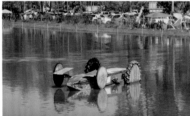

Chessers Don't Cry, 2013
During a preliminary heat on Sunday January 27, 2013, Glenn Chesser, son of Leonard, lost control of his buggy, Dat's On, and flipped it upside down. Trapped for only a few seconds, he burrowed his way through the mud with his helmet, despite the compound fracture to his arm. "I was down there long enough to talk to God," he said. "I thought about my grandbabies and how I wanted to get out of there to see them again." Glenn was taken by helicopter to a nearby hospital, where Dr. Patrick Leach, an orthopedic trauma surgeon, worked for nearly seven hours to save the arm from total amputation.

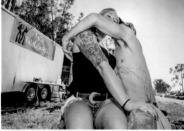

Kamp Feltersnatch, 2013

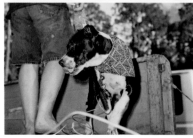

Rebel Dog, 2002

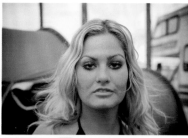

Bridgette, 2006
Bridgette was once described as a "heavy sipper."

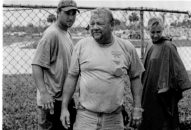

In Our Blood, 2002
Hershell Stalin stands in the pits with his wife Linda and their son Adam. The Hershell Family, which owns and operates Hershell's Crane Service, has been involved with the races for 30 years. Adam is currently building his own buggy.

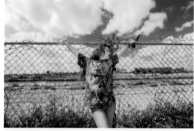

Camoflage, 2008

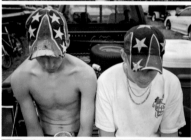

Hooks and Hats, 2006

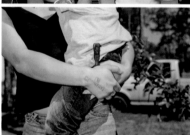

I'm Country, 2005

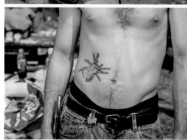

Tarantula, 2005

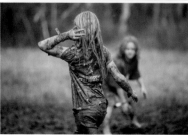

Mud Fight I, 2008

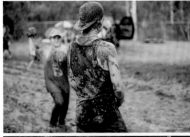

Mud Fight II, 2008

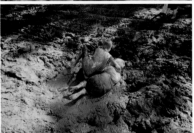

Mud Wrestling, 2006

Eddy Chesser, The Rapture, 2004
A Collier County road and bridge inspector, Eddy started racing swamp buggies in 1992 and has won 11 Budweiser Cup championships. The world championship of swamp buggy racing is determined annually by a points system. The driver that accumulates the most points in any calendar year is designated World Champion.

Leonard Chesser, Dat's Da One, 2004
Leonard Chesser, brother of Lonnie, is known as the godfather of swamp buggy racing. He retired in 2010 as "the winningest man in swamp buggy history." His daughter Amy was the first female to win a Big Feature in her buggy, Aches N' Pains.

John Bowman, Runnin' Ragged, 2004

Rod Kincheloe, 007, 2004

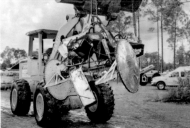

Busted Buggy, 2002
The buggy Hurricane, driven by Glenn Fillmore, broke in half after crashing.

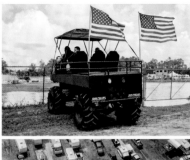

Stars and Stripes, 2002

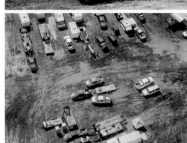

Trucks and Trailers, 2008

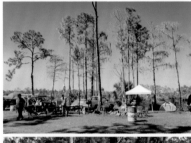

Under Cypress and Pine, 2011

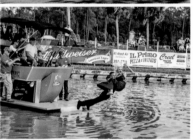

Mud Bath, 2011
Big Feature Winner Tyler Johns, driver of Patriot, takes the plunge into the Sippy Hole with Swamp Buggy Queen Christa Jo Roberts.

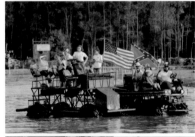

Waiting for the Mud Bath, 2013

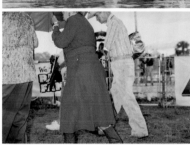

Maria Stone, Collier County Historian, 2002
Born in Plano, Texas, Maria Stone moved to Southwest Florida in 1949, where she taught fourth grade history in Punta Gorda for six years. She was my father's elementary school teacher. Stone spent two decades chronicling Collier County's past, detailing the lives of Naples' early black families, its migrant farmworkers in Immokalee, and the building of the Tamiami Trail, a highway that cuts through the Everglades and connects the Gulf and Atlantic coasts from Naples to Miami. She wrote a dozen books, including *Swamp Buggy Fever*, published in 1990. Stone wore a red dress, red boots, and a red hat to every Swamp Buggy Race. She died on Valentine's Day 2009 at the age of 86.

Blue Sky, 2013

ACKNOWLEDGEMENTS

THANK YOU MILE O' MUD KICKSTARTER BACKERS!
YOUR OVERWHELMING SUPPORT AND GENEROSITY MADE THIS BOOK POSSIBLE.

A & M

Adam Bell

Al & Luciana Ziegler

Alison Jarvis

Allen Frame

Alyssa Grebe

Anastasiya Lipatov

Andrew Pierce Fleming

Andy Bichler & Mindy Bichler-Greene

Ann Price & Ignacio Tortayada

Anna Lee

Art Brewer

Barbara Griffin

Barbra Pinx

Bill Armstrong

Bob & Linda Carey

Bonnie & Josh Porzio

Bonnie Yochelson

Bradley Crumb & Samantha Brooks

Brian Kelley

Brian Savitz & Jennifer Greene

Charles Traub

Cheryl Alander

Chris & Lisette Davidson

Christina Cahill

Clay McBride

Clickbooq Portfolio Websites

Clifford Hausner

Craig O Pearson

Dai Singleton

Dan & April Brooks

Dan Greenling (Roll On)

Dan Mcinnis

Daniel & Dawn Hoolihan

Danielle Lightner

David & Susan Calehuff

David Durand

David Gouldstone

David Rhodes

Dawny Sanders

Diana Dumitru

Don Hatfield Jr.

Donald & Kathy Lightner

Donald Lance Dawley & Graciela Bravo

Dr. Randi Frankel

Eleanor Oakes

Ellie Lowe

Eric & Meg Loffswold

Eva & Greg

Evan & Benjamin Anderson

Forest McMullin

Foto Care

George Blaze & Dawn Dailey

Glenn Christopher

Grant Taylor

Greg & Shu Bergman

Greg Pond

Gwen Parker

Isaac Diggs

Jackie & Jody

Jake Rowland

James Sanders

Jasmine & Lane Thorson

Jason Geller

Jason Mustain

Jeff & Jennifer Kirshner

Jen Cardenas

Jennette Williams

Jerry Vezzuso

Jimmy Moffat

Joanna Miriam

John Close

John Dumey & Morgan Porzio

John Law

Jonathan Carlee

Jordan Kleinman

Ken Shung

Ken Wahl

Kristin McElroy

Kyle May

Lauren Bohnen

Lauren Flynn

Laurie Anderson

Lee Hobson

Len DeLessio

Lisa Elmaleh

Lisa Sette

Lucas Thorpe & Nancy Rawlinson

Marc Havig

Maria Ruzic

Marina Tucker

Mark Von Holden

Marvin Lightner

Mary Smith

Matthew Arnold

Matthew Woodall

Megan Hoolihan-Dalziel (Swamp Buggy Queen, 2009-2010)

Michael & Teresa Hobson

Michael Mullen

Michelle Mercurio

Mike & Courtney Powell

Pace University Provost Office

Padgett Powell

Palmer Davis

Pamela Kogen

Paul & Eileen Pierce

Peter Garfield

Rachelle A. Dermer

Raj S. Chinthamani

Randall Connaughton

Ray & Lea Hale

Rea Bennett

Representative Matt Hudson

Rod Morata

Sardi Klein

Scott Marcotte Construction

Sean Grimes & Thelma Ferez

Sesthasak Boonchai

Seth Lambert & Dina Kantor

Stephanie Hunder

Stephen Frailey

Steve & Judy Alander

Steve & Sharon Hobson

Steve Warren

Sue Bailey

Swift Oil Change

Taleen Dersdepanian

Tammy Rose

The Condon family

The Reed Family

Tim & Kathy Smith

Toby, Jen & Don

Todd Sweet

Tom & Angela Engel

Tom Callahan

Tom P. Ashe

Trevor Thompson

Valeriya Vaynerman

Viana, Anna & Eugene Krupitskiy

Vinny Bogan

Will Warasila

Zach (Merdock) Mattei

Florida Sports Park, thank you for the press passes and unlimited access.

Drivers, thank you for welcoming me in the pits and into your homes and garages.

Fans, thank you for your hospitality, fine food, and unlimited cold beverages.

Bonnie Yochelson, thank you for helping me find structure and meaning, for keeping me on-track, and for your fine-tuned editing skills.

Charles Traub, thank you for your valuable feedback and for recommending that I charter a helicopter.

Stephen Frailey, thank you for your generosity and encouragement.

Padgett Powell, thank you for making the journey south of Orlando and for the exquisite introduction.

Blake Ogden, thank you for your scanning and retouching expertise.

Kiki Bauer, thank you for your design prowess, guidance, and patience.

Friends and colleagues, thank you for your continued camaraderie and humor.

To my dad Don and stepmother Kathy, thank you both for entertaining my photographic quest and for housing me and loaning me the car along the way.

To my mom Teresa and stepfather Mike, thank you both for your steady reassurance, encouragement, and faith.

To my wife Diana Dumitru, a very special thank you for your dedication to my photography and for knowing when to exercise "tough love" in order to keep me on-track.

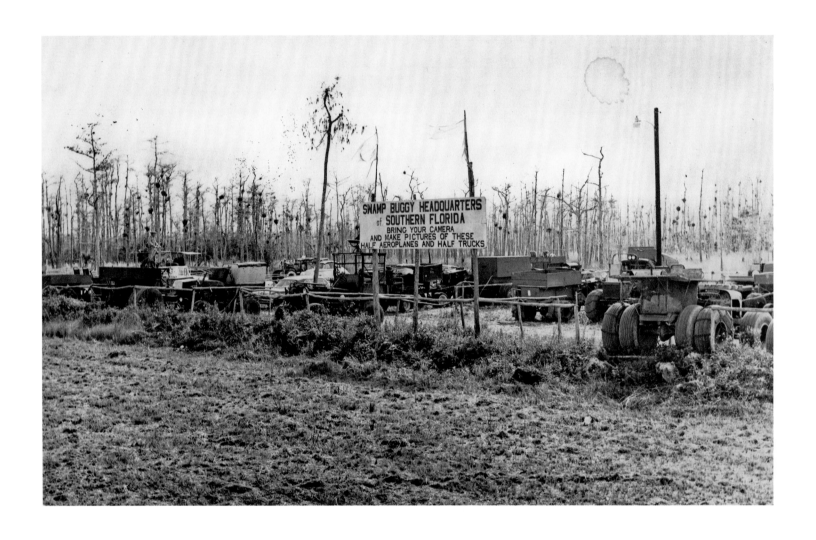

Swamp Buggy Headquarters, circa 1970.
Courtesy of Swamp Buggy Inc.

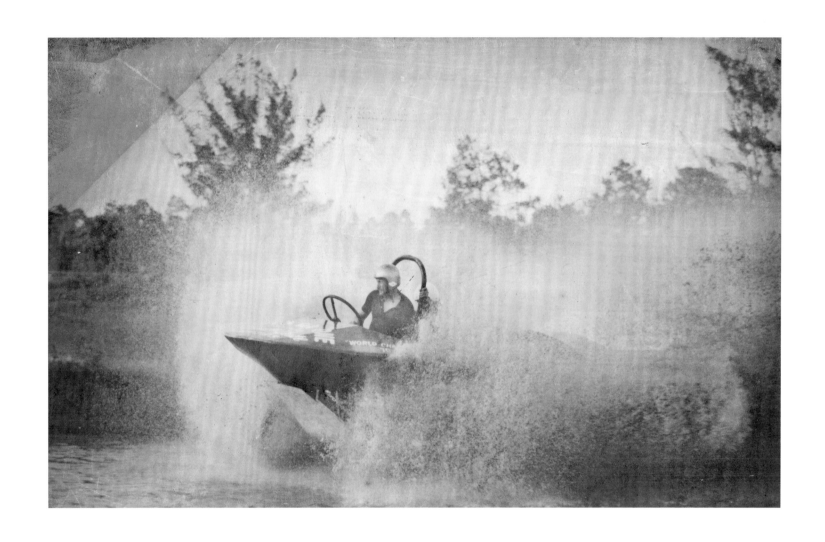

Leonard Chesser, Dat's Da One, circa 1970.
Courtesy of Swamp Buggy Inc.

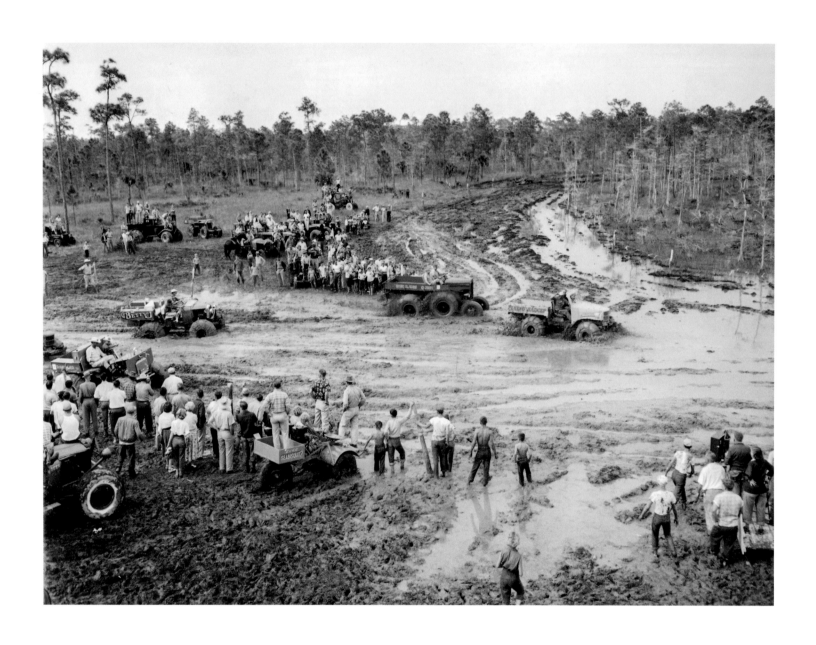

5th Annual Swamp Buggy Day Races. Photographed on November 8, 1953.
Courtesy of The Florida Photographic Collection

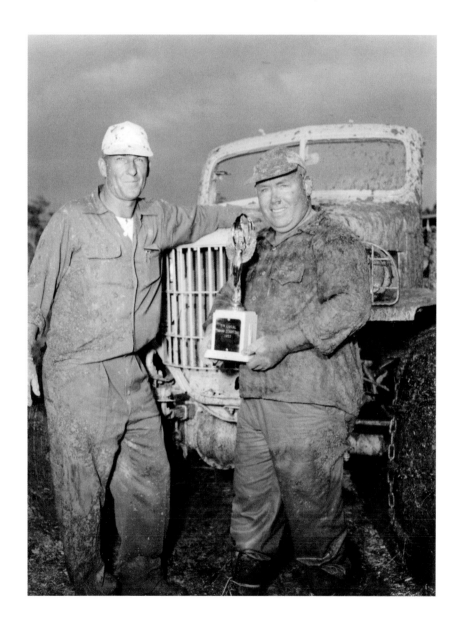

R.L. Walker and Fred Worth. Photographed on November 8, 1953.
Courtesy of The Florida Photographic Collection

opposite page, following spread
Contact Sheets, 1981.
Courtesy of Swamp Buggy Inc.

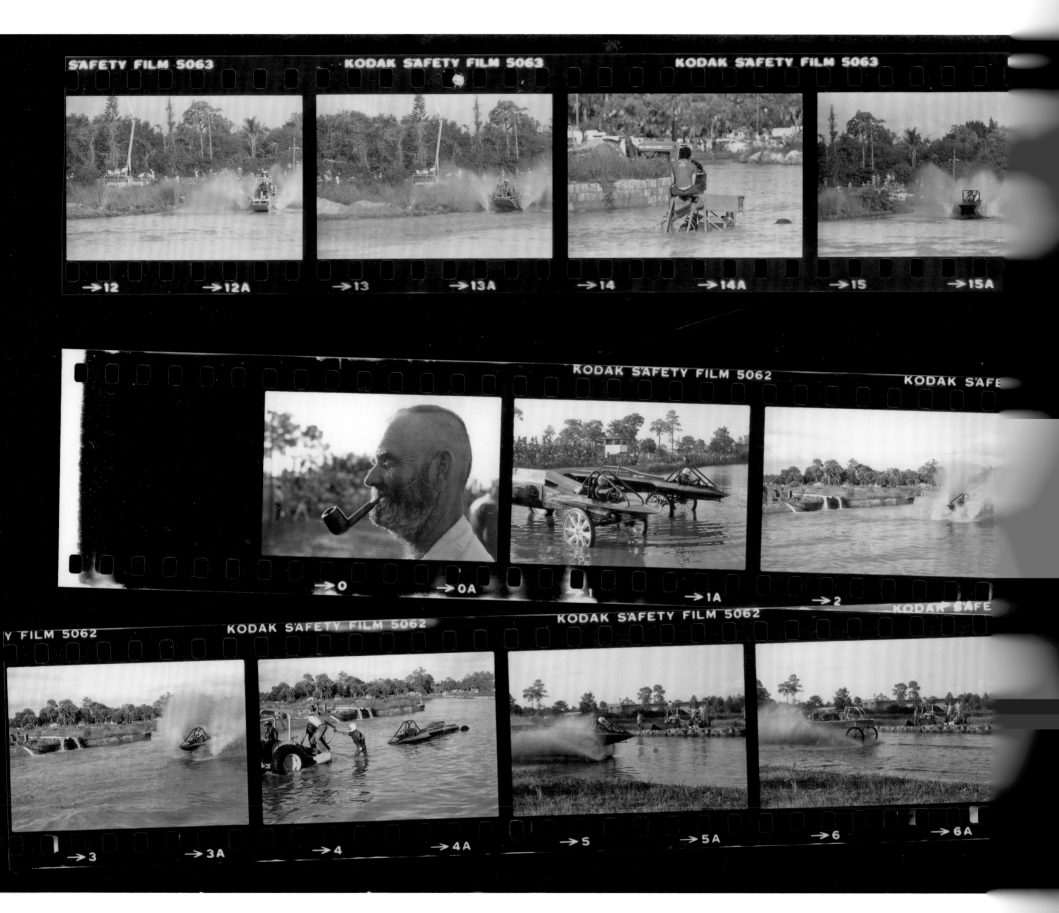

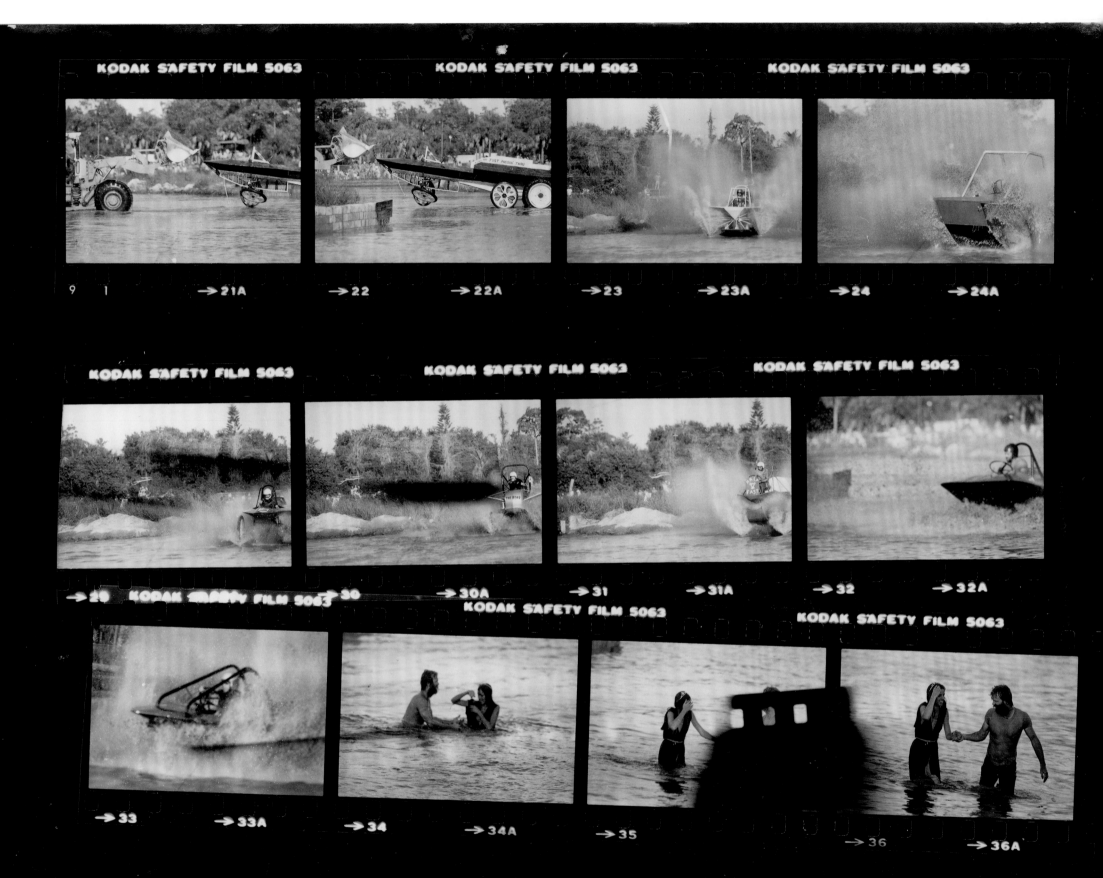

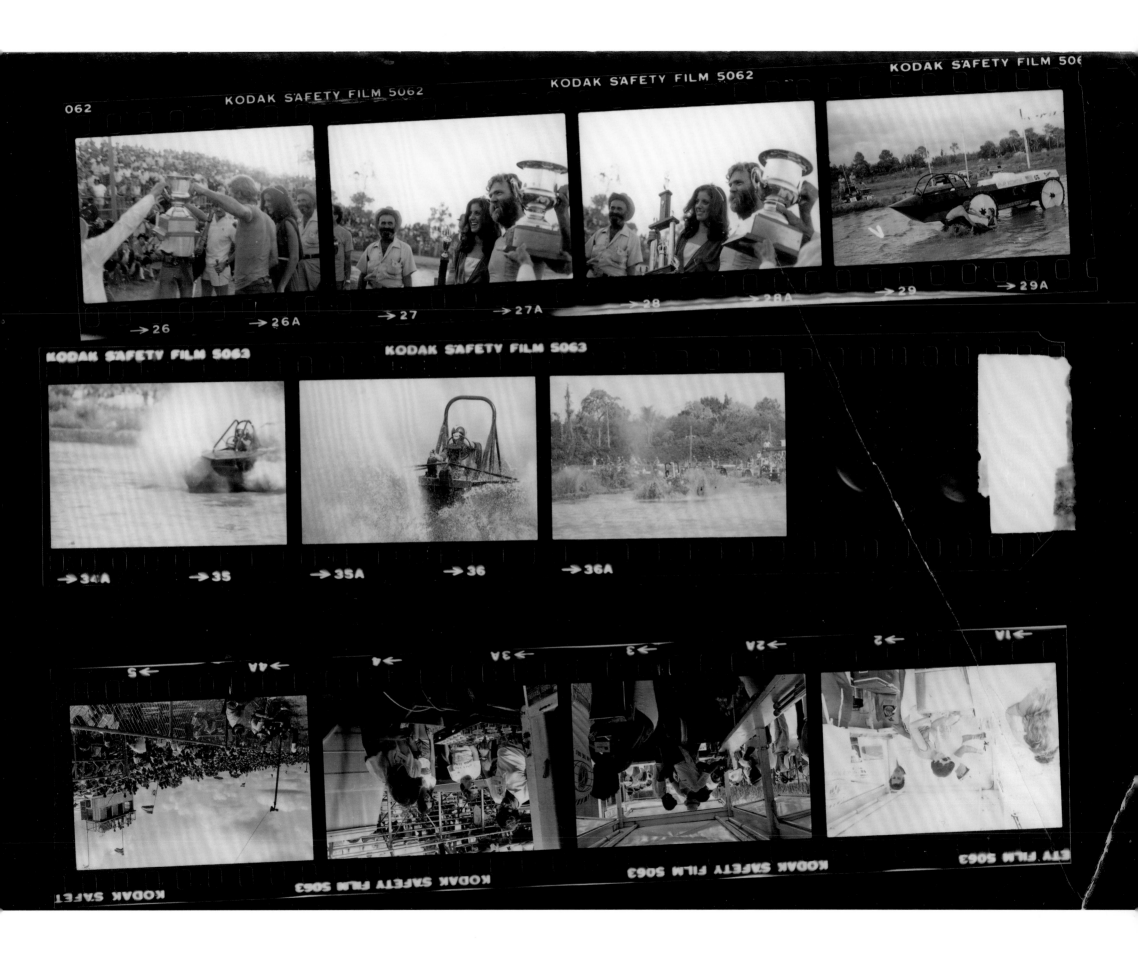

MILE O' MUD

Photography © 2016 Malcolm Lightner
Introduction © 2016 Padgett Powell

Published in the United States by powerHouse Books,
a division of powerHouse Cultural Entertainment, Inc.
37 Main Street, Brooklyn, NY 11201-1021
telephone 212.604.9074
e-mail: info@powerHouseBooks.com, website: www.powerHouseBooks.com

First edition, 2016

Library of Congress Control Number: 2015957410

ISBN 978-1-57687-794-4

Book design by Kiki Bauer with Malcolm Lightner

10 9 8 7 6 5 4 3 2 1

Printed and bound in China through Asia Pacific Offset

www.malcolmlightner.com